Gold Jewelry from Tibet and Nepal

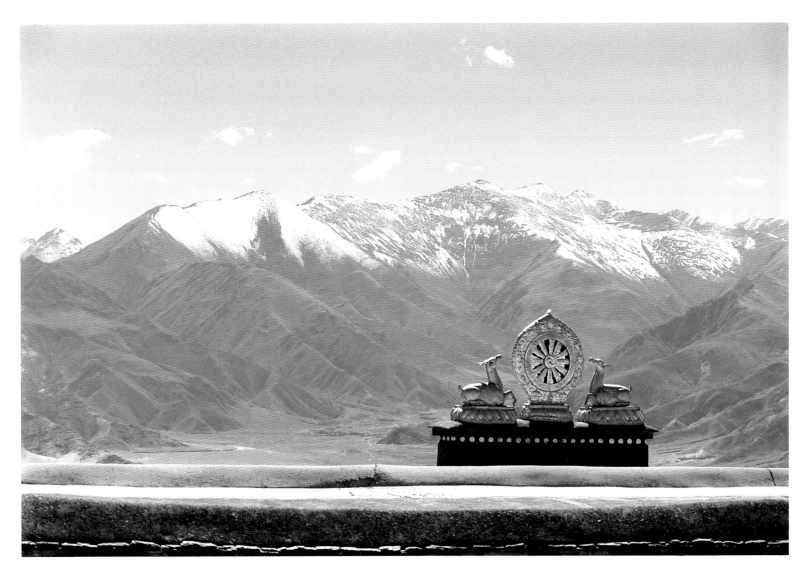

Fig. 1. View from the roof of the Jokhang Temple, Lhasa. Two deer flank the "Wheel of the Law" (*dharmacakra*), symbol of the Buddhist teachings.

Jane Casey Singer

Gold Jewelry from Tibet and Nepal

Thames and Hudson

First published in Great Britain in 1996
by Thames and Hudson Ltd, London

First published in the United States of America in 1996 by
Thames and Hudson Inc., 500 Fifth Avenue, New York, NY 10110

By arrangement with Edition Hansjörg Mayer, London

British Library Cataloguing-in-Publication Data

A catalogue record for this book is available from the British Library

ISBN 0-500-97442-X

Library of Congress Catalog Card Number: 90-70395

Printed and bound in Germany by Staib & Mayer, Stuttgart

Photographic Credits:
Liliane Lijn and Stephen Weiss, Fig. 1 and 2
Hansjörg Mayer, Fig. 5, 6, 7, 14, 16-20, 22-28, 30-32
Hughes Dubois, color plates 27, 39, 40, 43, 44, 46, 49, 52
Heini Schneebeli, color plates 1-26, 28-38, 41, 42, 45, 47, 48, 50, 51, 53-65

At that time, Śāriputra, the Buddhafield ... will be delightful, extremely beautiful, pure, prosperous, rich, quiet, abounding with food, and replete with the many races of man; it will consist of lapis lazuli and contain a checkerboard of eight compartments distinguished by gold threads, each compartment possessing a jewel tree ... perpetually filled with blossoms and fruits of the seven precious substances [gold, silver, turquoise, coral, pearl, emerald, and sapphire].

Śākyamuni Buddha describing paradise to his disciple, Śāriputra,
in the Saddharma Puṇḍarīka ("The Lotus of the True Law")

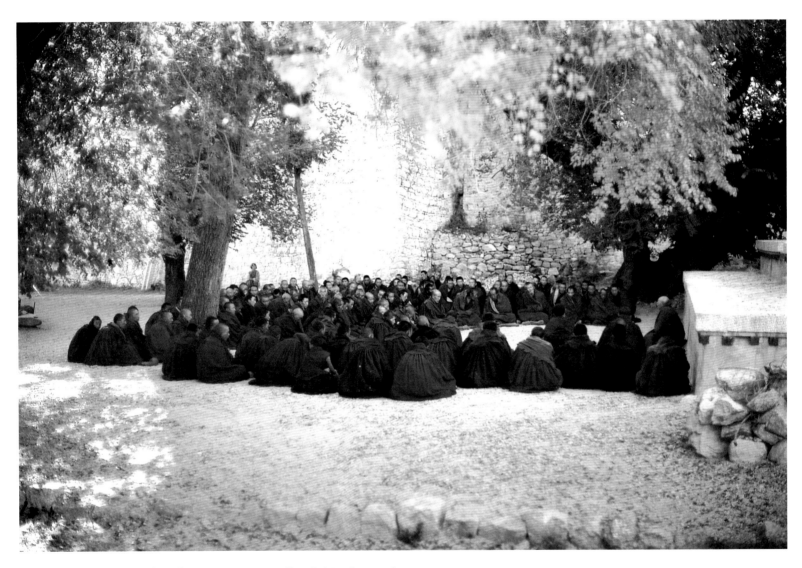

Fig. 2. Monks gather at Sera monastery (founded 1419), near Lhasa.

Contents

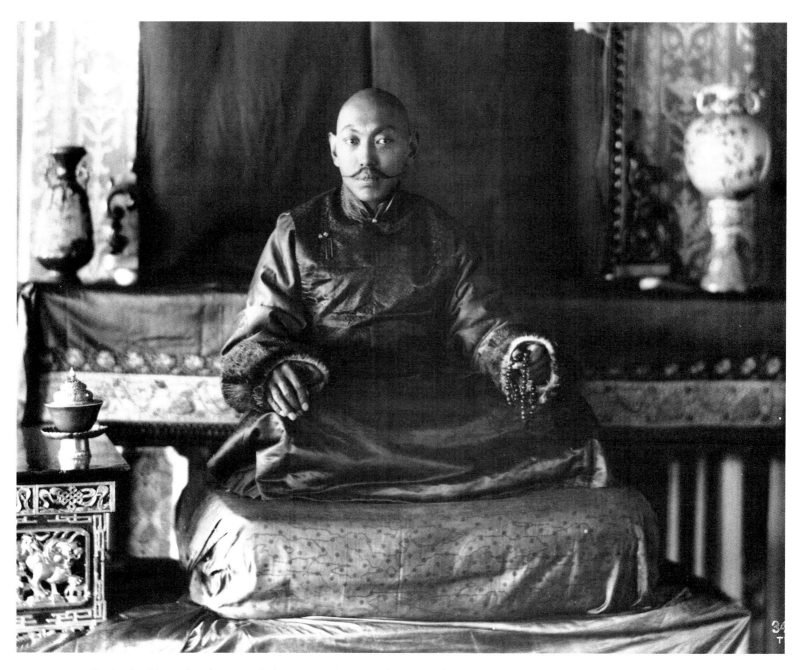

Fig. 3. The thirteenth Dalai Lama, Thubten Gyatso (1876–1933). Portrait taken in Darjeeling, ca. 1910–12.
Collection of the Newark Museum's Tibetan Archive, no. I-22-G. Competition for increasingly more extravagant jewelry became so financially burdensome to families that in 1929 the thirteenth Dalai Lama issued a decree limiting the expense which could be lavished on such ornaments.

Acknowledgements

I thank my esteemed colleague Ian Alsop, who read the Nepalese inscriptions on the amulets in nos. 10-13 and generously shared his considerable knowledge of the artistic and cultural heritage of the Kathmandu Valley. Dr. John Clarke, Assistant Curator of the Indian and Southeast Asian Collection at the Victoria and Albert Museum, London, kindly shared the fruits of his doctoral research on Himalayan metalwork and offered insight into the still mysterious monster mask motif.
Mr. Philip Denwood, Dr. Gyurme Dorje and Zenkar Rimpoche of the School of Oriental and African Studies, London University, answered countless queries about Tibetan linguistic puzzles and Mr. Phuntsok Tashi Takla, an historian and retired Tibetan army general now living in London, shed valuable light on the Tibetan system of government ranks.

Note on Foreign Terms

In this volume, Buddhist and Hindu terms most often appear in their more familiar Sanskrit forms. Tibetan words are spelled phonetically, often accompanied by accurate transliteration, and noted by "t".

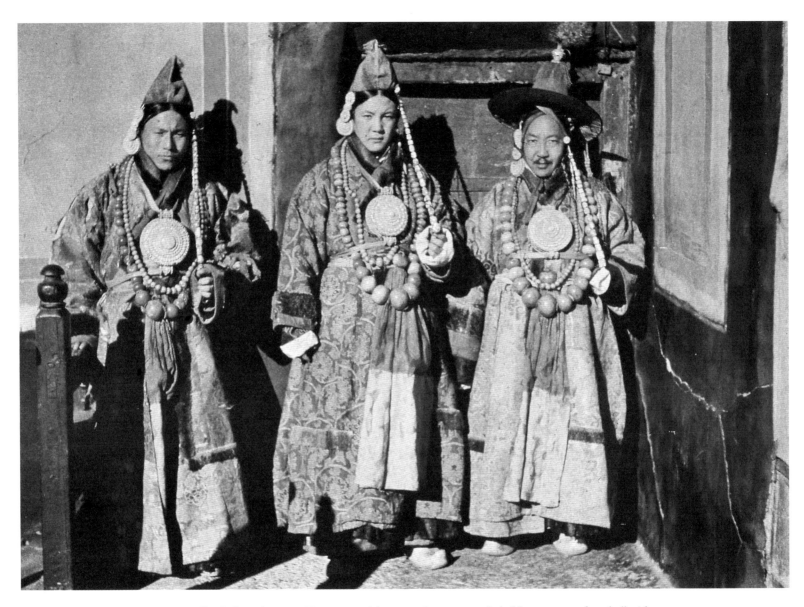

Fig. 4. Government officials dressed in New Year ceremonial costume known as *gyaluche* "the garment of royalty," with ornaments said to be the very ornaments once worn by Yarlung dynasty rulers (r. ca. 627–836). Photograph by Hugh Richardson, 1946.

Ornaments of Faith

More than any other art form, jewelry is created to indulge the ubiquitous human concern for personal vanity. It is often closely associated with a culture's aesthetic ideals. Jewelry's sensuous contours, the glistening patterns of its stones – even the materials from which it is made – all reveal a culture's impassioned views about what is beautiful. In the Himalayas jewelry also communicates social status and political power, its symbols convey ancient cultural values and, particularly in its form as amulet box, it serves a powerful talismanic function. Himalayan jewelry also reflects the great religious traditions of Buddhism and Hinduism. Both traditions were born in India, but made their way north into Nepal and Tibet many centuries before this jewelry was created. Tibet's cultural orientation is overwhelmingly Buddhist, while Nepal is predominantly Hindu, with pockets of Buddhist practitioners, particularly among the Newar people.

This volume includes some of the finest examples of gold jewelry to have been produced in the Himalayan region in recent centuries.[1] Most were created for Tibetan patrons; a few were clearly intended for the Nepalese, notably the amulet boxes adorned with Hindu iconography (nos. 1, 2, 3, 7, 8). Works such as the extraordinary Pendant (no. 23) reflect the syncretic mixture of Hindu and Buddhist traditions which characterizes much of Newar culture in the Kathmandu Valley. Newar craftsmen – long admired by their Tibetan neighbors for their superior skills in goldworking – created many of these works, reflecting an ancient tradition of artistic and cultural exchange between Tibet and Nepal.

Himalayan jewelry has never been thoroughly or even systematically studied, research being hindered by a lack of archaeological and literary evidence pertaining to Tibetan jewelry.[2] This contrasts sharply with the burial culture of China, where archaeological digs of dated tombs shed light on the evolution of personal ornaments, and royal court documents reveal their ritual function and social use.[3] Moreover, the ancient Tibetan culture which uniquely defined this jewelry has been all but destroyed during the Chinese occupation of Tibet, which began in 1950. In the course of research for this volume, many otherwise knowledgeable Tibetans were questioned about specific examples of Tibetan jewelry, but were unable to offer insight into their function or their significance. For this reason, it is not clear in every instance how the ornaments in this volume were used. No. 36, for example, is here described as Official's ornaments, but we have never seen photographs of such ornaments worn, and our Tibetan informants have not been able to explain their precise function. The information we do have about Himalayan jewelry largely derives from the observations of Western travelers to Tibet during the late eighteenth, nineteenth and early twentieth centuries, and from rare accounts written by Tibetans in exile. This introductory essay thus necessarily addresses only the most general ways in which jewelry was defined and appreciated in the Himalayas.

The Ornament as Metaphor

Within the Buddhist and Hindu traditions, gems and jewelry often serve as metaphors for ideals of the faith. Such metaphors hinge on notions of preciousness, rarity, and supreme refinement. Gems and jewels have long been regarded in this light and were therefore well-chosen analogues for the subtle, elusive spiritual states with which religious practice is concerned. To cite just a few examples, three essential aspects of Buddhism are described throughout the Buddhist world as the "three jewels" (*triratna*): the Buddha, his teachings (*dharma*), and the monastic community (*saṅgha*). The three jewels or a single pearl surrounded by flames is referred to as the "wish-fulfilling gem" (*cintāmaṇi*), a symbol which suggests Buddhism's power to satisfy our deepest desires. The attributes of a universal and spiritually enlightened monarch (*cakravartin*) are described as the *saptaratna* or "seven jewels," including the wheel (suggesting the power to bring about religious conversion), elephant and horse (indicating military might), wish-fulfilling gem, wife, minister, and general. The final phase of Indian Buddhism, which played an important role in Tibet and Nepal, was known as the *Vajrayāna* or "Diamond Vehicle," a reference to the diamond-like nature of the teachings and its path.

Jewelry and gems frequently appear in the titles of Buddhist treatises and in the titles bestowed upon Buddhist teachers and practitioners. The Tibetan Buddhist hierarch Gampopa (1079-1153) wrote a work on Buddhist practice called the Jewel Ornament of Liberation, its full title being the Explanation of the Stages on the Mahāyāna Path towards Liberation, called a Jewel Ornament of Liberation or the Wish-Fulfilling Gem of the Noble Doctrine.[4] Other important Buddhist titles include Bhāvaviveka's Jewel Lamp of the Mādhyamika, Maitreyanatha's Ornament of Emergent Realization, and Nāgārjuna's Jewel Garland. The title given to Tibetan teachers recognized to be the reincarnations of previous important teachers is *rinpoche* (t. *rin-po-che*), meaning "precious one" but also referring quite literally to a jewel or gem. And the bodhisattva, archetypical practitioner in *Mahāyāna* ("the Great Vehicle") Buddhism, is himself referred to as a jewel (*ratna*) in the Lotus Sūtra.[5]

Jewelry plays a significant role in Buddhist and Hindu iconography. The gods and goddesses of these traditions are richly adorned with abundant jewelry - crowns, earrings, necklaces, armlets, anklets, finger and toe rings. These ornaments are not incidental, but are iconographically prescribed because they are crucial to a deity's depiction. As Ananda Coomaraswamy has observed, the Sanskrit word for ornament, *alaṃkāra*, literally means making (*kṛ*) sufficient (*alaṃ*).[6] This Indian term suggests that ornament (jewelry in this instance) enhances and empowers the image, alerting the viewer to inner attributes otherwise hidden.

Within Hindu and Buddhist cultures, then, ornaments are powerful and they convey meaning. But does the fact that cultural icons (gods, goddesses, and bodhisattvas) wear jewelry have any impact on the design or wearing of jewelry by real people? Chinese Tang dynasty (618-907) records indicate that fashionable ladies adorned themselves in jewelry resembling that worn by images of bodhisattvas, in keeping with the Buddhist themes then currently popular at court. "Those who could not aspire to the profound self-abnegation of the *bodhisattva* could still dress the part, and stylish ladies ringed their necks

with torques and necklaces, wore hair ornaments that began to resemble *bodhisattva*'s crowns, chose jewellery decorated with Buddhist *apsarās* and lotuses, and ate to attain the *bodhisattva*'s buoyantly round, Central Asian form."[7]

Did Tibetans ever emulate their cultural icons in this way? We don't know. However, that their deities were lavishly adorned in jewels at least provided metaphysical support for their own adornment, in what might otherwise have been mere vanity[8] (figs. 5-7). L Austine Waddell noted during his visit to Tibet in the late nineteenth century that "some even of the higher Lamas wear ornaments and jewellery," citing in particular the Panchen Lama's jewelled necklace, later presented to the English emissary, George Bogle.[9] Moreover, there is some evidence that the bodhisattva's and other deities' jewelled adornment both reflected and influenced cultural perspectives on sensuality, with which personal adornment is closely linked.

Buddhist Attitudes Towards Adornment

Gautama Siddhārtha, the sixth century BC Indian founder of the Buddhist faith, was born a prince and had known great opulence but renounced his life of luxury to seek salvation through ascetic practice. He ultimately concluded that both sensual indulgence and physical deprivation are hindrances to spiritual evolution, teaching the Middle Way, a salvific path which was initially interpreted to mean isolation from the distractions of daily life by living in spiritual communities which were disciplined, but did not involve extreme deprivation.

Around the first century AD, Buddhist literature reveals a new emphasis on a wider or greater path (*Mahāyāna*), whereby the practitioner does not isolate him- or herself from worldly involvement, but fully embraces worldly experience as a means of testing and fortifying his or her spiritual understanding. The Vimalakīrtinirdeśa *sūtra* is representative of Mahāyāna literature in so far as it presents the layman Vimalakīrti's spiritual understanding as superior to that of the Buddha's leading monastic adherents, clearly surpassing them in lively debates.

The bodhisattva, one who seeks enlightenment while compassionately guiding others towards the same goal, features prominently in Mahāyāna Buddhism. Mahāyāna texts describe the bodhisattva's path as the cultivation of ten perfections (*pāramitā*), most requiring worldly engagement: generosity, moral integrity, patience, vigor, detachment, wisdom, compassion, determination, honesty and equanimity. The bodhisattva's path is beautifully described in Indian texts such as The Gaṇḍāvyūha *sūtra*. Upon the advice of the celestial bodhisattva Mañjuśrī, the young prince Sudhana travels widely throughout India in search of spiritual teachings. He encounters fifty-three persons of great wisdom from all walks of life, both professional religious instructors and laypeople. One of his teachers is the prostitute Vasumitra, an advanced bodhisattva. The Gaṇḍāvyūha *sūtra* and other texts like it persuasively argue the Mahāyāna view that there is no aspect of worldly involvement which need hinder spiritual evolution; in fact, for

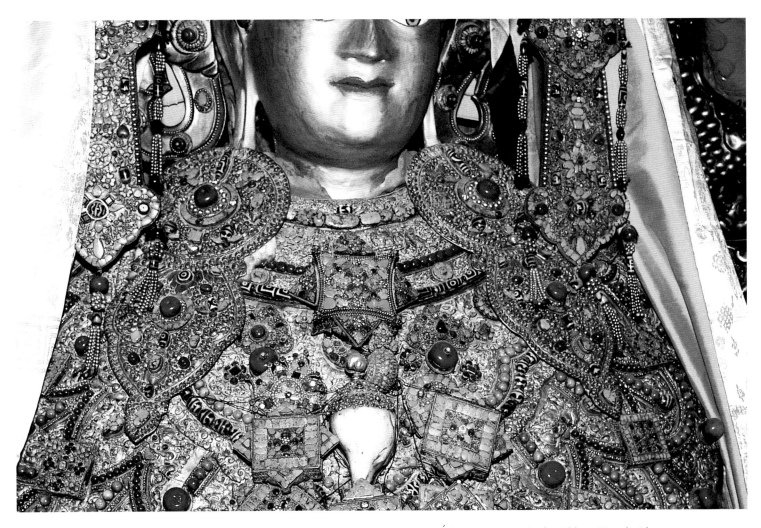

Fig. 5. Detail of gold and gem-encrusted ornaments adorning the torso of the Śākyamuni image in the Jokhang Temple, Lhasa. This image, known as the "Jo" statue, dates from the seventh century, when it is said to have been brought to Tibet from China by the Chinese Princess Wencheng. The great theologian Tsong Khapa is said to have arranged its lavish jewel adornment in 1409. Note the amulet boxes and monster mask ornaments which are very similar to examples in this volume.

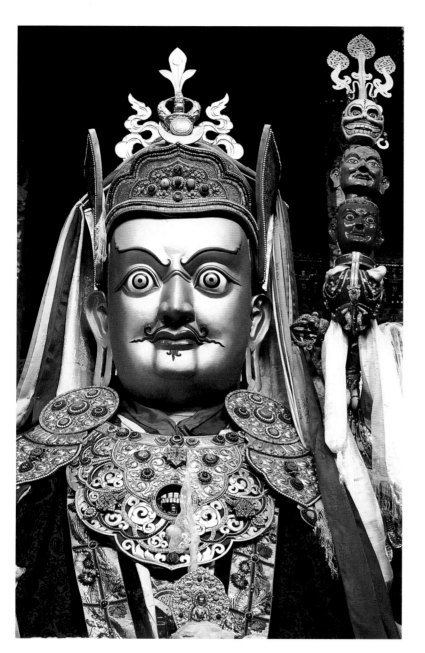

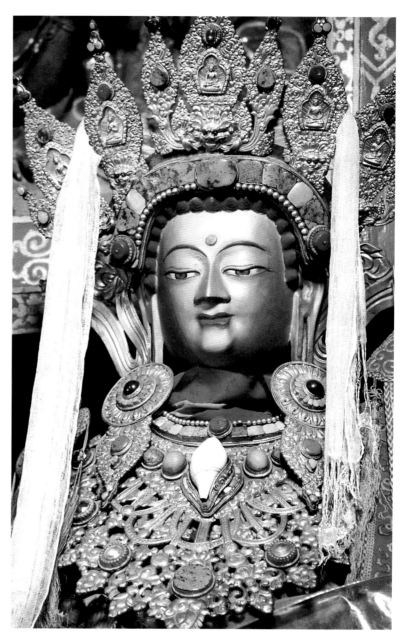

Fig. 6. Padmasambhava statue. Jokhang Temple, Lhasa. Note the gold and turquoise amulet boxes affixed to the image's necklace and earrings.

Fig. 7. Detail of gem-encrusted gold jewelry adorning an image in the Jokhang Temple, Lhasa.

some aspirants – like Sudhana – true spiritual understanding evolves out of a profound engagement in the full range of sensual experience.

The *arhat* ("elder"), the archetype of earlier Buddhist practice, had typically been described as shaven-headed, unadorned, and wearing the monk's robes required by his chosen path (fig. 8). In contrast, the bodhisattva as Mahāyāna archetype was adorned in princely ornaments including crown and earrings, necklaces, armlets, anklets and the like (fig. 10). The bodhisattva's jewel adornments can be interpreted as emblems of the spiritually enlightened, one who embraces life in all its diversity and enjoys the full richness that life can offer. This is a powerful view, one which goes to the heart of Buddhist and Hindu attitudes towards the relationship between sensuality and spirituality.

The preeminent Indian aesthete, Abhinavagupta (act. eleventh century), wrote eloquently about the similarities between aesthetic delight and spiritual rapture, stating that when the senses are satisfied, the heart blossoms. He observed that in the highest stages of aesthetic experience, one enters *paramānanda*, the highest bliss known also to mystics.[10] The difference between the aesthete and the mystic is that the aesthete's pleasure fades once the aesthetic object is withdrawn. The mystic reaches this state by rigorous training and can return again and again to the heights of spiritual rapture without recourse to sensual props.[11]

Such a world-affirming perspective has deep roots in both Buddhism and Hinduism. Asceticism plays a crucial role in these traditions, but is often restricted to necessary periods of training. Thus, when Śākyamuni left his father's palace at the onset of his quest for enlightenment, he sent back his horse and charioteer together with his ornaments, the latter symbolizing the worldliness and the vanity which he necessarily rejected at this stage in his spiritual search. The Buddhacarita recounts this episode:

> "... the mighty prince unloosed his ornaments and gave them to Chandaka, whose mind smarted with sorrow ... Taking from his diadem the blazing jewel, which performed the function of a light, he stood like mount Mandara with the sun on it, and uttered these words: 'With this jewel, Chanda, you must make repeated obeisance to the king, and in order to abate his grief you must in full confidence give him this message from me: I have entered the penance grove to put an end to birth and death, and not forsooth out of yearning for Paradise, or out of lack of affection or out of anger. Therefore you should not grieve for me, since I have left my home for this purpose.' "[12]

After years of strict ascetic practice followed by the recognition of its inherent limitations, the historical Buddha attained freedom from suffering in his great awakening, the enlightenment (*nirvāṇa*). And while images of the Buddha typically show him as an unadorned monk draped in simple robes, it is not uncommon to see images of the Buddha and his attendants both crowned and bejewelled (fig. 9). Such depictions reflect a doctrinal interpretation of his enlightenment as a coronation, in which Śākyamuni accedes to his fully awakened spiritual state in a ceremony not unlike that in which a king accedes to his throne.[13] The Buddha is always depicted with elongated earlobes, stretched by the wearing of heavy earrings when a prince; this physical attribute was incorporated into Buddhist iconography as one of the outward signs (*lakṣaṇa*) of an enlightened being.[14]

The Buddha's jeweled adornment can also be seen as a reflection of the splendour of his spiritual state. The Mahāvastu describes the seven days following Śākyamuni's enlightenment, during which time he remained seated under the bodhi tree while his astonishing achievement was acknowledged by countless witnesses. The Mahāvastu's account is of interest in this context for its repeated reference to jewels and gems:

> "... celestial jewels rained down from the sky ... the *bodhi* throne was surrounded by a bejewelled ground which the devas fashioned in the centre of the Buddhafield ... All men and women in the Buddhafield turned towards the *bodhi* tree of the great Seer ... All gems of precious stones, celestial and rare, ornaments of devas, turned [in that direction]. The jewels of Nagas, Yaksas, Pisacas and Raksasas turned towards the immovable *bodhi* tree ... Anklets, bracelets and armlets turned towards the immovable *bodhi* tree of the Buddha who won Enlightenment. Necklaces ... and lovely strings of pearls, the adornments of human beings, all turned towards the immovable *bodhi* tree. Strings of pearls, brilliant adornments, earrings of gems, draperies and signet-rings all turned towards the immovable *bodhi* tree. All the inconceivable beings in the Buddhafield, wittingly or unwittingly, turned towards the immovable *bodhi* tree."[15]

However, lest we think that adornment or the absence thereof is in itself necessarily significant, the Mahāvastu proffers the tale of two wandering mendicants who were impressed with miracles performed by one of Śākyamuni's disciples, the richly adorned guild-president's son, Yaśodā.

> "... Seeing such various and diverse miracles of magic performed by Yaśodā ... [they] were astonished, amazed, excited and thrilled that the well-proclaimed dharma and discipline of the exalted Gotama had been revealed ... They said, 'This is what comes of adornment, this is what comes of faith. For when this man was taken up by his father he was dressed all in white, wearing garments of pure Benares cloth. His body was anointed with sandalwood ointment and he wore bracelets and earrings. And now he has realised the dharma.' Then on that occasion the Exalted One made this solemn utterance touching Yaśodā, the guild-president's son: 'Not baldness, nor matted hair, nor mire, nor fasting, nor lying on the bare ground, nor dust and dirt, nor striving when one is squatting on the ground brings freedom from ill. Though he be brightly arrayed, if he lives the life of dharma, calm, tamed, restrained, living the brahma-life, forbearing to use violence against all creatures, then he is a brahman, a recluse, a monk.'"[16]

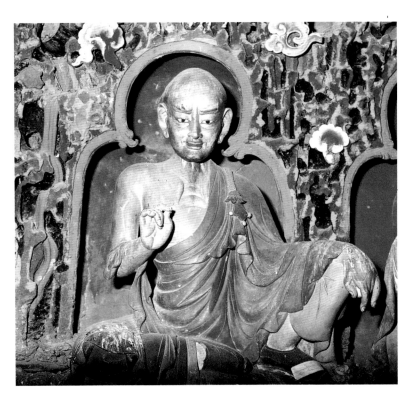

Fig. 8. Arhat, from a chapel in the Gyantse Kumbum, Central Tibet, ca. 1440.

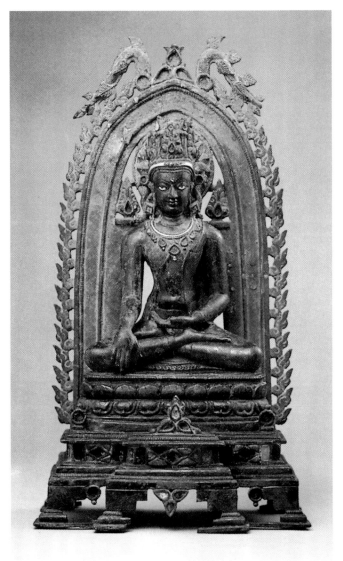

Fig. 9. Seated crowned and jeweled Buddha. India (Bihar), Pāla period, Kurkihar style, late tenth century. Bronze inlaid with silver, lapis lazuli, and rock crystal. H. 32.4 cm. Gift of Miriam and Ira D. Wallach Foundation, 1993. The Metropolitan Museum of Art, New York.

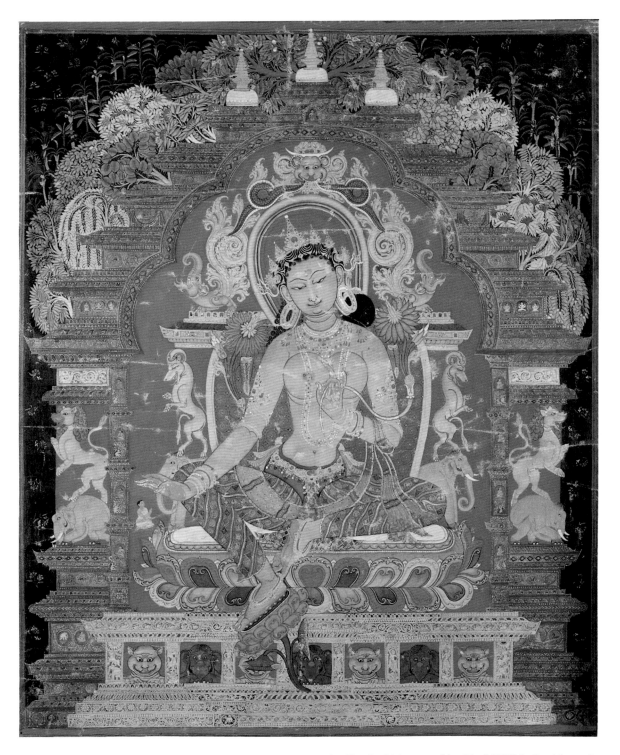

Fig. 10. Tārā. Painting on cloth. Central Tibet, ca. 1300. 52.1 x 43 cm. The Cleveland Museum of Art, The J.H. Wade Fund, by exchange.

19

Ornaments as Indicators of Wealth and Power

These lofty theoretical associations do not exclude other, more mundane significance for Himalayan jewelry. Gold jewelry is rare, affordable only to the wealthy and the powerful. Its rarity suggests exclusivity, distinction, superiority. Heinrich Harrer remarked that higher ranked army officers distinguished themselves from the lesser ranks by the number of gold decorations they wore.[17] Tibetan society was extremely hierarchical and jewelry could reflect not only one's personal wealth, but one's precise social and political status as well.

The Lhasa nobility trace their ancestry to the early Tibetan monarchs (r. ca. 627-836), to powerful local chiefs, and to the Dalai Lamas; outstanding service to the government could also ensure ennoblement. In the 1940s, Harrer estimated that the Lhasa nobility consisted of about two hundred families.[18] These wealthy landowners guided their sons into the monasteries and into the civil service where, depending on their abilities and their efforts, they could rise to positions of considerable power. Noble women were married into other aristocratic families in order to preserve the families' wealth. "If necessary, all the daughters of one [noble] family would marry one man, or one daughter could take several husbands. Marriage arrangements were primarily a matter of acquiring and retaining power and property." [19]

Hugh Richardson, representative in Lhasa of the British Government of India and subsequently representative of the independent Government of India between 1936 and 1950, witnessed the role of ornaments in the rarefied circles of the Lhasa aristocracy. He noted that on the third day of the New Year, a woman could be fined if she appeared outside her home without her ornamental headdress.[20] A noble woman's jewelry reflected her husband's government rank. Harrer wrote that " ... every man was obliged to present his wife with the jewels corresponding to his rank. Promotion in rank entailed promotion in jewellry! But to be merely rich was not enough, for wealth did not confer the right to wear costly jewels."[21] He estimated in 1955 that a cabinet minister's wife might wear jewelry worth as much as $ 20,000.[22] Competition for increasingly more extravagant jewelry became so financially burdensome to families that in 1929 the thirteenth Dalai Lama (1876-1933) issued a decree limiting the expense which could be lavished on such ornaments.[23] When the Dalai Lama died in 1933, people soon disregarded the unpopular law.[24]

Male government officials also wore ornaments, each so carefully prescribed that Harrer could determine the rank of lay officials by their dress and ornaments.[25] In 1931, Charles Bell noted the Lhasa civil service to consist of approximately three hundred and fifty officials, roughly half lay (t. *drung-'khor*) and half ecclesiastics (t. *rtse-drung*).[26] The administration was organized into eight ranks, most positions filled by two officials, one layman and one monk.[27] The first rank consisted of the office of the Prime Minister, filled by a layman and a monk. The Prime Minister's hat bore a pearl at the apex. The civil branch's chief executive body consisted of four Cabinet Ministers in the second rank, their hats distinguished by a ruby at the top.[28] The religious branch was headed by the Chikyap Khenpo (t. *spyi-khyab mkhan-po*), who served as head of the Dalai Lama's household and oversaw matters of protocol.

The third rank included up to ten officials who headed government departments including Military, Treasury, Judicial, Foreign, and Education; most posts were shared by monk and lay officials whose rank was indicated by a coral at the top of their hats.[29] The fourth rank consisted of approximately seventy to eighty officials, mostly laymen, who carried out much of the day-to-day responsibilities in the Lhasa government. Sons of Cabinet Ministers and relatives of the Dalai Lama would enter the civil service at this level and, depending on their abilities and industry, would rise accordingly. The lacquered hat with vase finial surmounted by a turquoise-colored stone in no. 42 is an example of the ceremonial summer hats worn by lay officials of the fourth rank[30] (fig. 15).

The fifth rank consisted of thirty or forty officials, mostly mayors, heads of administrative districts, members of the judiciary, and various commissioners. Representatives of this rank, like those of the sixth through the eight ranks, could wear any non-precious stone in their hats, excluding those stones worn by the ranks above. Sometimes, their hats bore no differentiating stones. Official clothing also reflected rank. The first rank through the top tier of the fourth rank wore robes of yellow or gold silk brocade; the remainder of the fourth rank and all of the fifth rank wore maroon silk garments; the sixth through the eighth ranks wore black woolen clothing.

All government officials donned their best clothes and ornaments for ceremonies throughout the official year, with a formal ceremony in the Potala marking the change from winter to summer official dress.[31] Lay government officials wore elegant, thin turquoise and pearl earrings (t. *so-byis*) in their left ears[32] (nos. 30, 31) (figs. 11, 12, 15, 21). Small, turquoise-studded amulet boxes (t. *skra-gor* or *ta-gab*) such as those in nos. 28 and 29 were worn in the braided hair of lay government officials of the fifth rank and above.[33] (figs. 13, 21). Lay officials also wore turquoise pendants consisting of an orb or disc surmounted by a monster mask, the iconography of which is discussed below[34] (nos. 37–40) (figs. 11, 12). In 1947, Harrer witnessed the procession accompanying the Dalai Lama as he moved from the Potala to his traditional summer residence, the Norbu Lingka ("Jewel Park"). He wrote: "Everyone of importance accompanied the [Dalai Lama] to Norbu Lingka. The entire Government followed the palanquin in order of rank, riding horses with saddles of gold. It was an unforgettable spectacle, the profusion of gold and silks and jewels drenched in vivid sunshine under a cloudless sky."[35]

Some ornaments worn by lay officials are clearly rooted in ancient customs. Hugh Richardson described a ceremony known as "The King's New Year" which he attended in 1946. On this day, lay officials wore the *gyaluche* (t., *rgya-lu-chas* "garment of royalty"), said to be modelled on costumes worn by the ancient princes. In the Dalai Lama's procession were thirteen officials wearing seventh- to ninth-century court-style dress, their leaders adorned in exceptional jewelry said to be the very ornaments once worn by Yarlung dynasty rulers (r. ca. 627-836) (fig. 4). These ornaments included enormous turquoise and amber necklaces, massive gold and turquoise amulet cases, and turquoise and gold ear pendants consisting of thunderbolt scepters (*vajra*) surmounting discs made of turquoise and gold. The ornament in no. 46 resembles the thunderbolt scepters in these ear ornaments and may have served a similar function. These *gyaluche* ornaments were kept in the Potala treasury, and a member of the government cabinet carefully supervised their temporary loan for this special ceremony each year.[36]

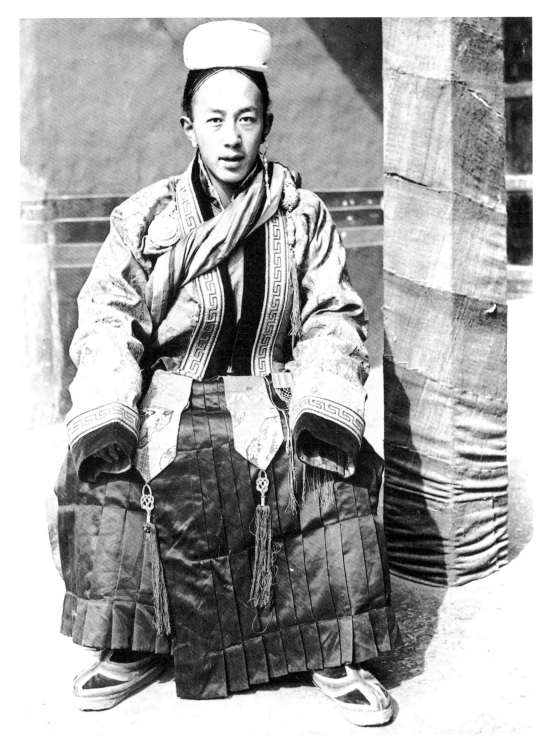

Fig. 11. Tibetan government official in the *gyaluche* dress worn during New Year's ceremonies.
Photograph by Frederick Spencer Chapman, ca. 1936–37.

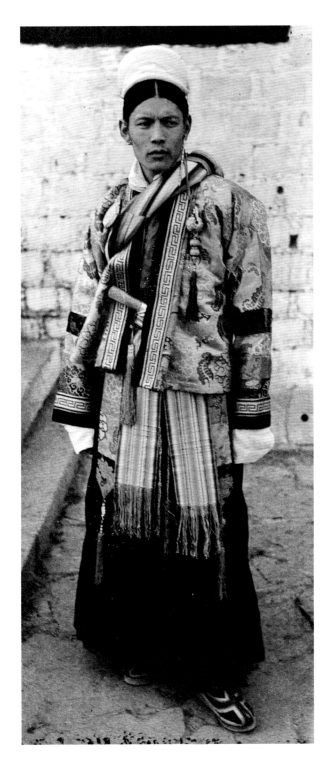

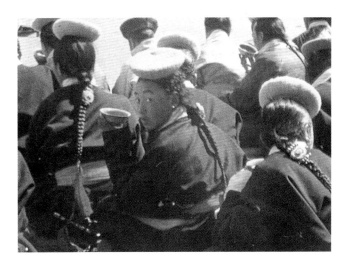

Fig. 13. Government officials of lower ranks with amulet boxes in their braided hair, Lhasa, ca. 1936–37. Photograph by Frederick Spencer Chapman.

Fig. 12. Government official in *gyaluche* dress. Photograph by Frederick Spencer Chapman, ca. 1936–37.

Fig. 14. Tibetan man wearing large gold and turquoise earring, Gyantse, 1985.

23

Some ornaments presented here are remarkable simply because they are gold versions of objects usually made from less precious materials. Portable shrines (t. *ga'u*, often made of silver or brass) and rosaries (often made of bone, wood, or seeds) are common in Tibet, those in nos. 25 and 26 being notable for their fine workmanship and for their unusual rendering in gold. Similarly, the man's earring in no. 27 would have been worn by a wealthy Tibetan, those of lesser means having worn a similarly designed earring in silver or brass (fig. 14). It was customary for Tibetan men to wear an earring in their left ears; those who did not were said to risk reincarnation as a donkey. The earrings in nos. 32, 34, and 35 are usually described as men's, but research indicates they can also be worn by women.[37]

Gold in whatever form also served as a ready form of cash, particularly outside Tibet where Tibetan paper currency was essentially worthless. Bell noted that a "well-to-do" woman's dowry would typically include "a gold charm-box, a pair of gold earrings, a head-dress of coral and turquoise for daily use, another set in pearls for use on occasions of high festival or ceremony ... and other varied ornaments."[38] A woman's jewelry collection, frequently worn in its entirety on her body, served a kind of personal financial portfolio (fig. 36).

Personal Jewelry Adorning the Tombs of the Dalai Lamas

A fascinating but poorly understood aspect of Tibetan personal jewelry involves its appearance on tombs of the Dalai Lamas in the Potala. One remarkable room in this seventeenth-century building contains a 14.5-meter-high golden reliquary (*stūpa*) containing the embalmed body of the fifth Dalai Lama, Ngawang Lobsang Gyatso (t. *ngag-dbang blo-bzang rgya-mtsho*, 1617-82).[39] This massive structure dominates the chamber, flanked by smaller reliquaries containing remains of the tenth Dalai Lama (1816-37) and the twelfth Dalai Lama (1856-75). Other reliquaries surround these, said to contain relics of the historical Buddha. These extraordinary structures are decorated in the grandest Tibetan style, replete with gold and encrusted with gems. The fifth Dalai Lama's tomb alone is reputedly covered with 3,724 kilograms of gold and encrusted with over 1,500 pearls and precious stones.[40]

Remarkably, these tombs are also adorned with men's and women's personal jewelry, symmetrically arranged along their surfaces, top to bottom[41] (fig. 20). The thirteenth Dalai Lama's (1876-1933) reliquary is adorned with women's ear pendants similar to those in no. 50 (figs. 16-20). Women's ear pendants like those in nos. 48 and 49 appear on earlier tombs - e.g., those of the eleventh (1838-56) and twelfth (1856-75) Dalai Lamas, supporting the view that they represent an earlier style of ear pendant. Also on the thirteenth Dalai Lama's tomb are amulet boxes similar to those in nos. 54–56, government official's earrings like those in nos. 30 and 31 and monster mask ornaments like those in nos. 39 and 40 (figs. 16-20).

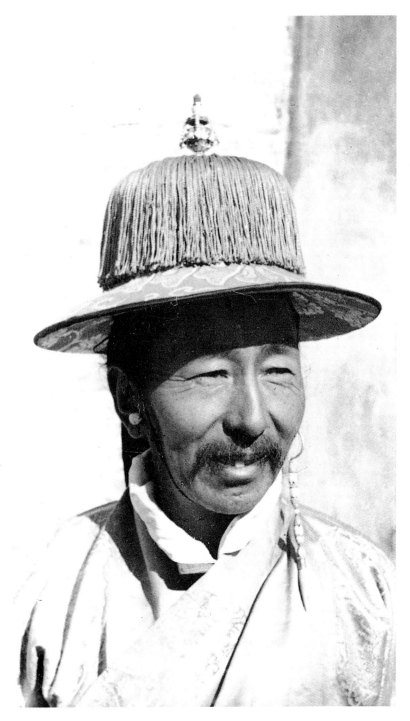

Fig. 15. Government official wearing a summer hat.
Photograph by Frederick Spencer Chapman, ca. 1936-37.

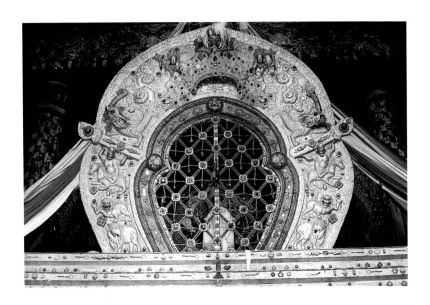
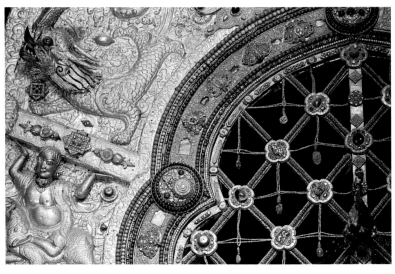
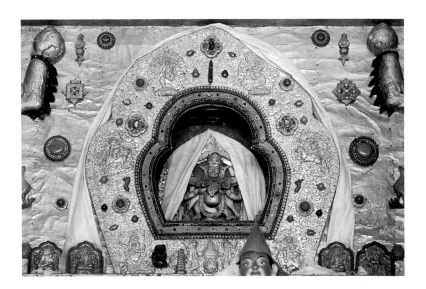

Figs. 16-19. Details from the tomb of the thirteenth Dalai Lama, Thubten Gyatso (1876–1933), the Potala, Lhasa. Note the women's ear pendants, amulet boxes, and other examples of personal jewelry embedded in its gold surface.

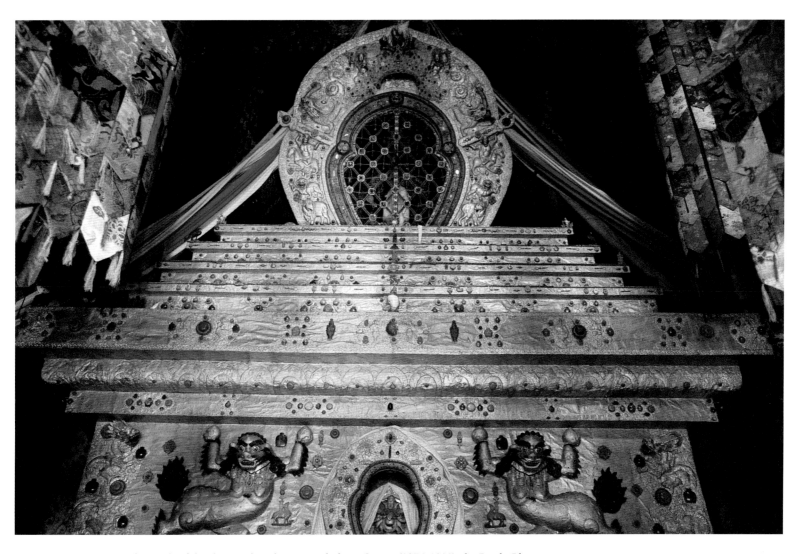

Fig. 20. The tomb of the thirteenth Dalai Lama, Thubten Gyatso (1876–1933), the Potala, Lhasa.
The tomb contains the embalmed body of the Dalai Lama. Its surface is encrusted with personal jewelry donated by devotees both during his lifetime and upon his death.

Why do personal ornaments decorate the tombs of the Dalai Lamas? Tibetans have suggested that members of the aristocracy were invited to donate personal jewelry to adorn the tomb of a recently deceased Dalai Lama.[42] What did they gain by doing so? Within a Buddhist context, all donation is meritorious, but was there particular significance associated with this type of donation? The Lotus sūtra mentions jewelry as appropriate adornment for the reliquaries of saints:

> "Shall we give a gift of piety ... to the Bodhisattva?" The [Buddha Śākyamuni] replied: "Do so"... Then the bodhisattva Akshayamati took from his neck a pearl necklace, worth a hundred thousand (gold pieces), and presented it to Avalokiteśvara as a decoration of piety ... accepted the pearl necklace from Akshayamati, out of compassion ... Thereafter he divided (the necklace) into two parts, and offered one part to the Lord Śākyamuni, and the other part to the jewel Stūpa of the Lord Prabhūtaratna, the Tathāgata, who had become completely extinct."[43]

The psychological effects of placing one's own jewelry on the tomb of a powerfully sacred figure such as a Dalai Lama are easily imagined. One associates one's self, symbolized by one's personal jewelry, with the sacred in perpetuity. The Indian cultural historian Gregory Schopen describes a related phenomenon within Indian Buddhism, whereby a practitioner's bodily remains and personal effects are placed in reliquaries near sites where the historical Buddha was thought to have been, or where his own relics are thought to have been interred.[44] Schopen argues that the faithful believed that a powerful spiritual presence existed in such places, and that real spiritual benefit could come to one who placed themselves, their physical remains, or their personal symbols in close physical proximity to the holy site. It is perhaps not irrelevant to note that a gold and sapphire bracelet, encased within a clay ball, was found below the enlightenment throne at the Mahābodhi Temple in Bodh Gayā during its 1880–81 restoration.[45] The significance of the bracelet in this location has not been explained but it may have served a similar purpose, the bracelet acting as a tangible link between the donor and the sacred – in this instance, the site of the Buddha's enlightenment. Examples of this phenomenon also exist within Japanese Buddhism. A dense jumble of graves and markers surround the tomb of Kōbō Daishi (774–835), the revered founder of Shingon Buddhism. Describing this practice in Japan, U A Casal notes that "not all the graves contain a [practitioner's] body or ashes; it suffices to bury a bone, or even some hair or a tooth. The important thing is that one's symbol be interred near the great teacher." [46] Might the presence of Tibetan jewelry on the Dalai Lamas' tombs reflect an awareness of this pan-Asian Buddhist practice? Further research will help to clarify the close association between personal ornaments and Tibetan reliquaries of saints.

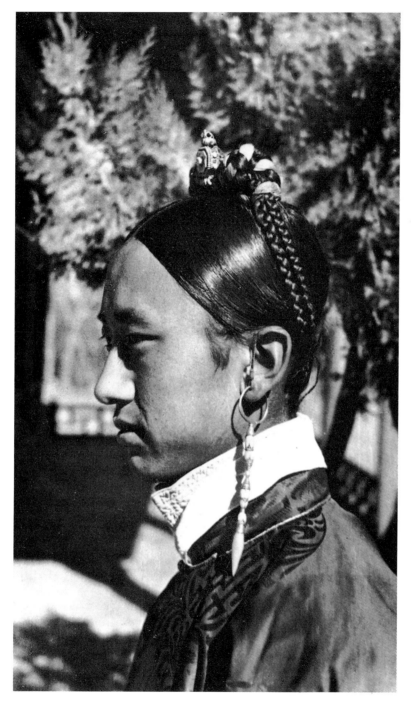

Fig. 21. Government official wearing an amulet box in his braided hair. Only higher ranking government officials could secure their braids on top of their heads. Note the hair ornaments, like those in no. 59 below. Photograph by Frederick Spencer Chapman, ca. 1936-37.

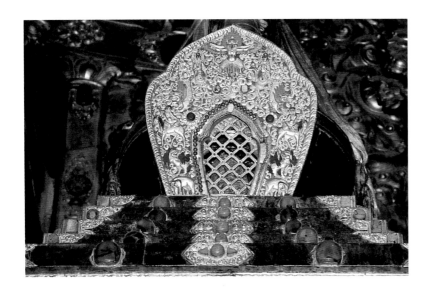

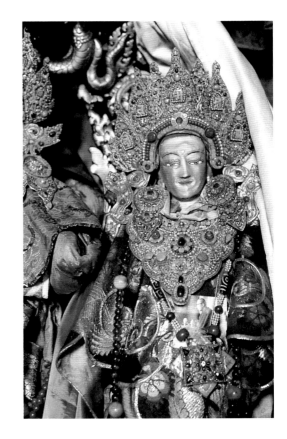

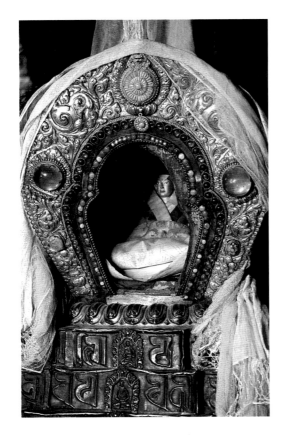

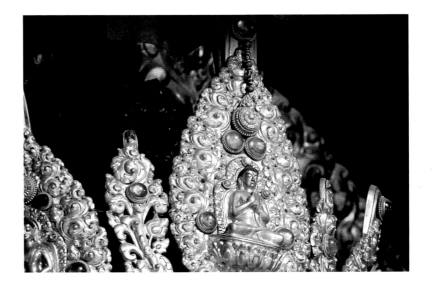

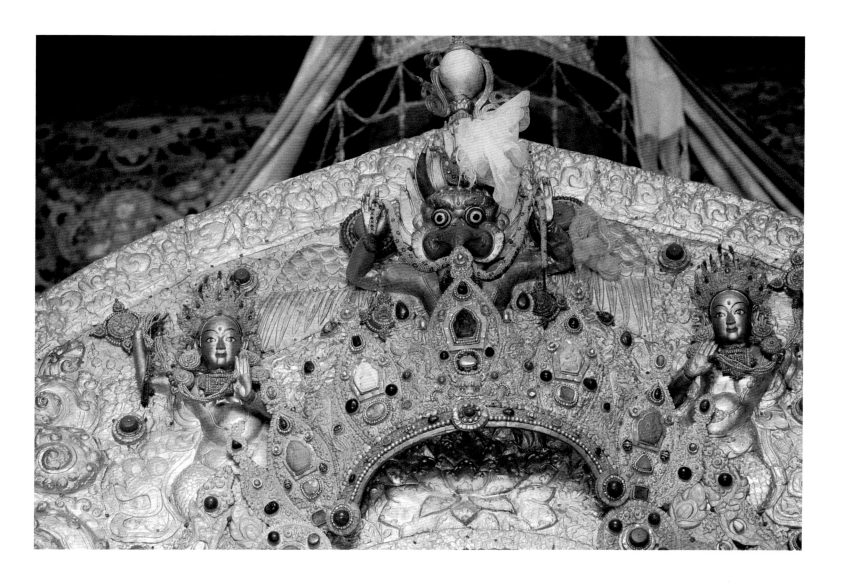

Figs. 22-26. Details of bejewelled imagery from Tashilungpo monastery, the Potala and the Jokhang Temple.

Materials and Mastercraftsmen

Although gold is plentiful in Tibet, Tibetans believe it is difficult to extract because earth deities (t. *sa-bdag*) resent disturbance of the soil.[47] Similar superstitions were also held by the Mongols and the Chinese in ancient times.[48] A traveler to Tibet in the early part of this century noted that "Tibetans have extraordinary superstitions regarding the extraction of the precious metal [gold], and on this account they will only collect gold dust and spangles. They say that nuggets and seams are the parents of the dust and spangles, and should they interfere with the former, the supply of the latter will cease. They believe that should the earth be disturbed overmuch in the mining of gold, ill-fortune will visit not only the country, but also the person of the Dalai Lama ... and crops would fail."[49]

We don't know precisely how Tibetans extracted gold from their rich native deposits, nor in what quantities.[50] Two chief means for obtaining gold were at their disposal: carefully prescribed quarrying, and the less invasive method of collecting gold along riverbanks. Heinrich Harrer observed Tibetans using gazelle horns to dig for gold. He remarked that the Tibetans refrained from hoarding gold, taking only the minimum required. Such restraint was also noted by the thirteenth-century Franciscan monk, William of Rubruck, who wrote: "These people have much gold in their country, so that when one lacks gold he digs till he finds it, and he only takes so much as he requires and puts the rest back in the ground; for if he puts it in a treasury or coffer, he believes that God would take away from him that which is in the ground."[51]

W W Rockhill, in Tibet during 1891-92, had the opportunity to observe Tibetan nomads collecting gold along riverbanks. He wrote: " ... the gravel was shoveled into a wooden trough, about four feet long and six or eight inches broad at the lower end; through it a little stream of water was allowed to flow. Across the lower end of the trough was stretched a thick woolen rag through which the water escaped. The mud and gravel in the trough were stirred up with a stick and gently removed with the hand, while the particles of gold set free were caught in the rag. Every now and then the rag was removed, the gold collected and put in a yak horn snuff bottle ..."[52]

Tibet's fascination with gold dates from its early history. In 640, tribute from the Tibetan ruler Songtsen Gampo (t. *srong-btsan sgam-po*, r. ca. 627-49) to the Chinese Emperor Tai Zong included splendid vessels fashioned out of gold. The following year, Songtsen Gampo sent a seven-foot-high gold wine jug in the form of a goose.[53] In 658, the Chinese emperor received an even more extraordinary gift of gold – a replica city filled with horsemen, elephants, and other animals.[54] Chinese literary sources describe ninth-century Tibetan rulers living in tents decorated with tigers, leopards, and other animals fashioned out of gold.[55] It is no wonder that China has long regarded Tibet as a rich source of gold; gold dust was a leading Tibetan export to China until recent times.[56]

The early Tibetan monarchs (r. ca. 627-836) worshipped in rites involving animal sacrifice and the offering of turquoise and gold.[57] Early Tibetan and Chinese texts describe the ritual burial of these monarchs, stating that a ruler was buried in "the attire and the precious stones he had enjoyed; and the horse he had ridden, his bow and sword – all this was buried with him."[58] An early Tibetan history,

Official Scrolls of the Kings (*rgyal-po bka'i thang-yig*), contains a lengthy description of burial rites performed at the tomb of Songtsen Gampo:

> "... having covered the king and his two wives with gold leaf, they placed them in silver caskets. The king was placed on his throne on the central square of the tomb and they piled up in front of him a load of gold, of silver and of turquoises as well as the wealth from his treasury. They set up silk hangings, canopies, parasols and banners of victory, and having arranged everything properly so nothing was missed, they affixed a sevenfold series of seals so nothing should be broken open."[59]

This tomb has yet to be excavated, although Chinese and Tibetan archaeologists have begun excavations of smaller tombs from this period.[60]

Tibetans' delight in gold and its aesthetic properties can be seen in its liberal use on images made of lesser metals. The gilding of Tibetan statues - from all periods - is extremely common. Moreover, the roofs of temples and other religious sanctuaries are often gilded, the seventh-century Jokhang temple and the seventeenth-century Potala, residence of the Dalai Lamas, being among the most famous examples (fig. 27).

Highly prized by the Tibetans, turquoise is used liberally in the jewelry in this volume. Turquoise is native to Tibet, although the darker stones obtained from Iran were of finer quality.[61] The official headpiece in no. 41 is an immensely appealing mosaic of turquoise, each piece carefully matched in color.[62] A less ambitious but fully satisfying example of this turquoise mosaic can be seen in no. 29, a small amulet box worn in the hair of lay government officials, mentioned above. Coral is also immensely popular; Marco Polo (1254?-1324?) had noted the Tibetan penchant for coral, worn by "women and ... their idols."[63] Tibetans have traditionally preferred deep red stones such as those seen in the magnificent necklace in no. 57, although lighter colored coral, also imported from Italy, has become popular in recent times. Lapis lazuli, mainly from Afghanistan, has long been popular among Tibetans; Chinese Tang dynasty (618-907) sources indicate that Tibetan men and women wore bits of lapis in their braided hair.[64] Amber, long imported to Tibet from the Baltic region, sometimes appeared in lavish necklaces as huge golden discs (figs. 4, 38).

<div align="center">★</div>

Gems hold medicinal properties, which may have influenced their use in amulet boxes and in other jewelry as well. The Blue Beryl, an important Tibetan medical treatise written by Sangye Gyatso (t. *sangs-rgyas rgya-mtsho*, 1653-1705), explains that even gold itself is thought to possess restorative qualities: "stringent and cooling, it increases longevity and dispels demons."[65] Turquoise's healing properties are said to include the alleviation of poisoning and all "heat" diseases associated with the liver.[66] "Pearl prevents brain disorder and alleviates poisoning. Conch dries out pus, and can cure fever of the bones, as well as benefitting the eyes ... Red coral alleviates fever of the liver and the channels, as well as fever caused by poisoning. Lastly, lapis lazuli ... alleviates leprosy."[67]

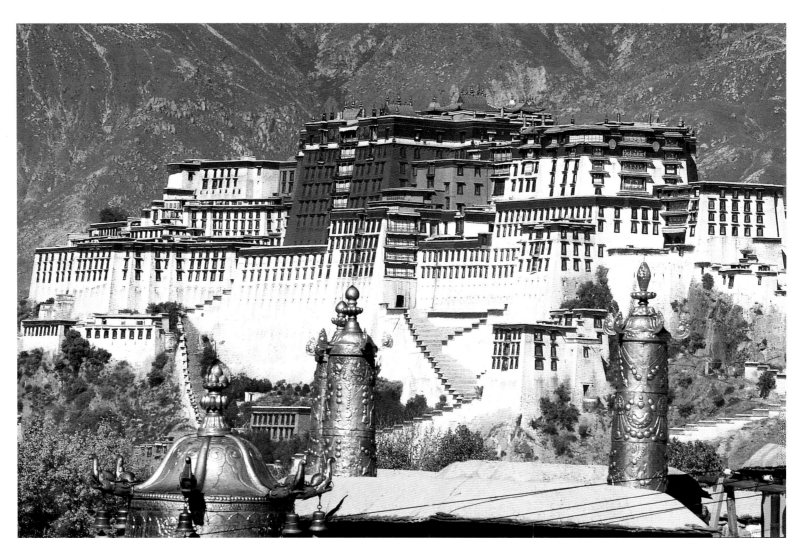

Fig. 27. View of the Potala from the roof of the Jokhang temple, Lhasa.

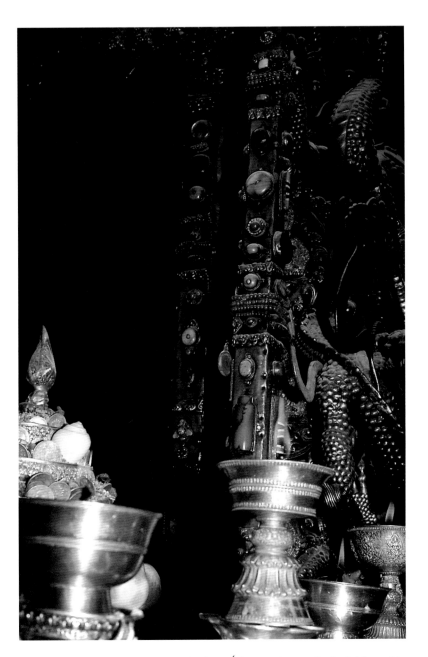

Fig. 28. Gold butter lamps burn aside the *Jo* Śākyamuni statue in the Jokhang, Lhasa.

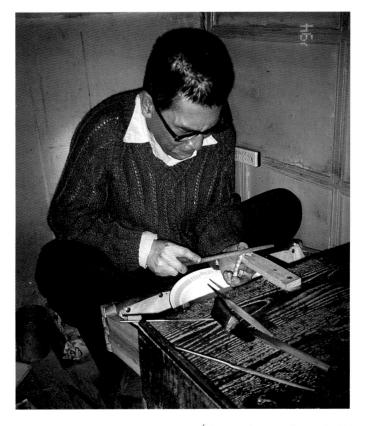

Fig. 29. Newar goldsmith Dhama Jyoti Śākya working in Lhasa, July 1994.
Photograph by Ian Alsop.

In their medical application, these gems would have been ground and used in concoctions, but benefits may nevertheless have accrued when the gems were worn externally on one's person. Still, one must not overlook the fact that these stones have enjoyed enduring popularity in Tibet largely because of their immediate sensual appeal. Tibetans love these materials and respond to their colors, their luminosity, their feel in the hand and their appearance against the hair and skin.

Newar Craftsmen

Newars are likely to have produced much of the jewelry in this book. While Tibetan metalworkers produced fine jewelry, most sources concur that the finest jewelry was produced by Newar craftsmen, whose superior skills as goldsmiths (notably their filigree work and their handling of inset stones) are consistently praised in the literature.[68] For over a millennium, Newars have settled in Tibet where they were employed by Tibetan Buddhist patrons. During the period of the fifth Dalai Lama (1617-82), Newars were among the artists recorded in the prestigious government workshop of metalworkers (t. *rdod-bzo dpal-'khyil*), located at the foot of the Potala.[69]

Newars also established private workshops in Lhasa near the center of the city (t. *bar-'khor*), where they served thousands of monks in the Lhasa region, as well as a large lay community.[70] According to a Lhasa jeweller now living in exile, before the Chinese invasion there were about one hundred jewelers in the capital, perhaps fifteen of whom were capable of excellent work, with just a few of these employed for the particularly discerning nobility.[71]

Traditionally, many Newar men whose livelihood regularly brought them to Tibet married Tibetan women. Their children were called *katsara* (t. *ka-tsha-ra*), a Tibetan term for the Nepali *kaccara*, "mule of mixed blood."[72] According to Charles Bell, there were over one thousand *katsaras* in Lhasa in 1921.[73] He noted that large numbers of *katsaras* could also be found in the surrounding cities of Lhatse, Shigatse, Tsethang and in Kongpo province, in southeast Tibet. The Nepalese in Tibet maintained their own religious and cultural societies known as Pala or Para associations. "In Tibet, every Nepalese family in Lhasa and Shigatse had to delegate a representative to the Para. Each Para had its own meeting place which had often given [the Para] its name. There were still 8 active Para in Lhasa in 1959, one of which had 200 members and was over 225 years old."[74]

Thus, although they underwent successful acculturation in Tibet, the Newars maintained ties with the Kathmandu Valley and never completely relinquished their own beliefs, a mixture of Hinduism and Buddhism. This may have relevance for the jewelry in this book, because the Hindu iconography on some of the amulet boxes indicates Newar patronage (nos. 1-3, 7, 8). It is difficult to determine whether they were worn by Newars in Nepal or Tibet, or even whether they were made in the Kathmandu Valley or in Tibet. The similarly shaped boxes adorned with Buddhist iconography (nos. 4-6, 9-14, 20, 22) may also have been worn by Newars.[75]

The amulet boxes and some of the other gold jewelry presented here were created by repoussé, a metalworking technique which flourished in the Kathmandu Valley as early as the seventh century AD.[76] The name itself loosely translates from the French *repousser*, "to beat again." This technique demands great skill of the artist, as the material actually worked upon is metal, a surface particularly unforgiving of mistakes. A sheet of metal must take the imprint of the craftsman's chisels and punches, beaten again and again against a pitch of wax and resin. Most surviving repoussé work from Nepal is in copper or brass, although it is often gilded. Examples of repoussé jewelry in volume are exceptional because they are rendered in gold. In some cases, the thin amulet boxes retain in their interiors the waxy pitch against which the gold sheet was originally beaten to produce its form (nos. 1-9). Other amulets boxes are empty and include small openings by which amulets can be inserted into the case (nos. 10-22). In a few instances, amulets are still contained within the box, although they are not necessarily contemporaneous with the box itself (nos. 10-13).

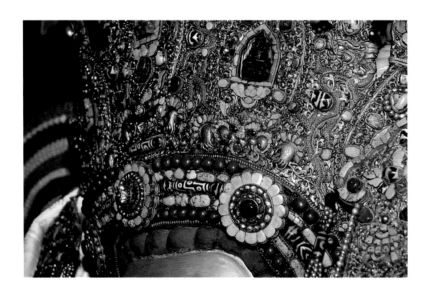

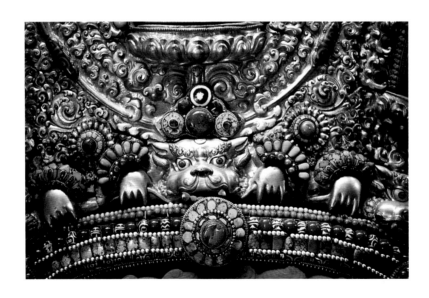

Figs. 30–31. Details from crowns of the *Jo* Śākyamuni statue in the Jokhang (top) and an image in the Potala (below).
Note the monster masks repeated along the base of both crowns.

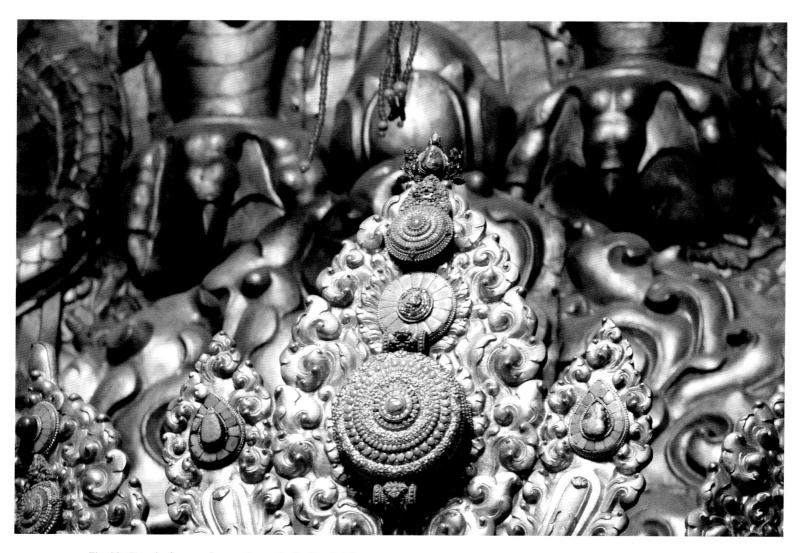

Fig. 32. Detail of crown from an image in the Potala, Lhasa.
Note the gold and turquoise amulet box and the monster mask ornament affixed to the leaves of the crown.

The Iconography of Himalayan Jewelry

Those familiar with Buddhist and Hindu iconography will recognize many of the symbols and deities on the jewelry in this volume. The exquisite ornament in no. 46, probably worn by a government official, bears the eight auspicious emblems of Buddhism (t. *bkra-shis rtags-brgyad*).[77] This common group includes the umbrella (symbol of royalty and sacred persons); two fish (suggesting the emancipation of the spiritually liberated); the conch shell (a symbol of the Buddha's word); the lotus (long associated with spirituality in both Buddhism and Hinduism); the wheel (suggesting the perpetuation of the Buddhist teachings); the standard of victory (heralding the attainment of enlightenment); the vase (containing immortal elixir and representing fulfillment of one's highest aspirations); and the noose or endless knot (symbolizing longevity and the interrelation of all of life). At the centre of this assembly is the wish-fulfilling gem mentioned above, and its handle is adorned with the thunderbolt sceptre (*vajra*), symbol of the adamantine nature of the Buddhist teachings. The conch (no. 47), clearly meant to be worn as a pendant (note the two holes to enable suspension), also bears the eight auspicious symbols.

The Monster Mask Motif

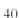
Garuḍa

The symbol described in this catalogue as "monster mask" requires a more lengthy explanation. Typically worn by lay government officials, its iconography combines elements from two Indian images - the Garuḍa bird and the *kīrtimukha* ("face of glory"). Garuḍa, the mythic solar bird, possesses talismanic properties associated with his being a natural enemy of serpents, potent symbols of evil in Indian myth. Half-bird and half-man, the winged Garuḍa holds a serpent in his beak and outstretched arms. He is thought to protect against diseases associated with water and other illnesses connected with serpents.

The *kīrtimukha* originates in mythic tales involving a titan king, Rāhu his emissary, and the powerful Hindu god, Śiva. Hindu myth recounts the story of a great titan king named Jalandhara who, through powers gained in yogic practice, had conquered all the gods and controlled their realms tyrannically.[78] He sent an emissary to the chief god, Śiva, demanding Śiva's wife Pārvatī for himself. His emissary was Rāhu, the Hindu demon who eclipses the moon. At the beginning of time, Rāhu had gathered with other gods and titans to churn the cosmic ocean, preparing to extract from it the elixir of immortality. Rāhu snatched the first sip, and was immediately beheaded by Viṣṇu. But the elixir had already passed through Rāhu's head and neck, and they became immortal. While the rest of his body decayed, Rāhu's head remained ravenous for more elixir; he was condemned to forever chase the moon, the cup containing immortal elixir. On the occasions that he manages to catch the moon, we mortals witness the moon's eclipse. Since Rāhu has no stomach with which to retain the moon, it passes directly through him and quickly reappears.

This mythic association between Rāhu and the moon is relevant to the monster mask symbol in Tibetan jewelry because often the monster mask is placed on top of an orb or disc which could be interpreted as a moon (nos. 37-40). In this form, the monster mask is especially close to Rāhu. But this still does not explain the symbol's attraction for government officials. The monster mask's appeal in government circles may stem from another part of the *kīrtimukha* mythology, when *kīrtimukha* takes on talismanic powers. When Rāhu related Jalandhara's demand for Pārvatī, Śiva responded angrily. From his third eye burst forth a ferocious lion-headed demon. The frightened Rāhu instantly appealed to the benevolent side of Śiva, begging for mercy. Śiva spared Rāhu. But this left the ferocious lion demon with nothing to appease his hunger, and a substitute had to be found. Śiva told the lion monster to feed on his own body. He did so, voraciously devouring his body until all that remained was his leonine head. This head remained as a reminder of the ferocious, protective power of Śiva. Śiva said to the leonine face: "You will be known, henceforth, as 'Face of Glory' (*kīrtimukha*), and I ordain that you shall abide forever at my door. Whoever neglects to worship you shall never win my grace."[79]

In India, the link between the *kīrtimukha* and Śiva gradually weakened as the *kīrtimukha* became associated with other talismanic functions, particularly with the protection of thresholds. It became a standard element in Buddhist and Hindu iconography, regularly appearing for example in the thronebacks of deities. In its Indian form, the *kīrtimukha* consists of a leonine mask which lacks a lower jaw. In Tibetan jewelry, the leonine mask incorporates other elements, probably from the Garuḍa bird – arms and hands, and a snake held in its mouth. The monster mask's face often resembles that of Garuḍa, its beak prominently featured[80] (nos. 36-40). Occasionally, its leonine associations are clearer, as in no. 22, where a mane is suggested by striated turquoise. It sometimes emits gems from its mouth and lacks a lower jaw (no. 16).

These hybrid forms are all referred to by the Tibetan terms *chimindra* (t. *chi-mi-'dra)*, *zirdong* (t. *gzi-gdong)* and *tsipa* (t. *rtsis-pa)*. Eleanor Olson noted that some of these hybrid forms may also have roots in the Chinese *tao tie* masks seen on ancient Chinese bronzes.[81] Schyller Cammann's research has indicated that the monster mask is sometimes associated with Māra, the Lord of Death.[82] In Tibetan art, all three iconographic types – the Indian *kīrtimukha*, the Garuḍa bird and the Tibetan hybrid forms of the monster mask – are used, often interchangeably, at the top of thronebacks and in other talismanic contexts. The monster mask's popularity among government officials may stem from the *kīrtimukha's* mythic function as emissary of the powerful god Śiva, as well as from his more general association with protection and auspiciousness.

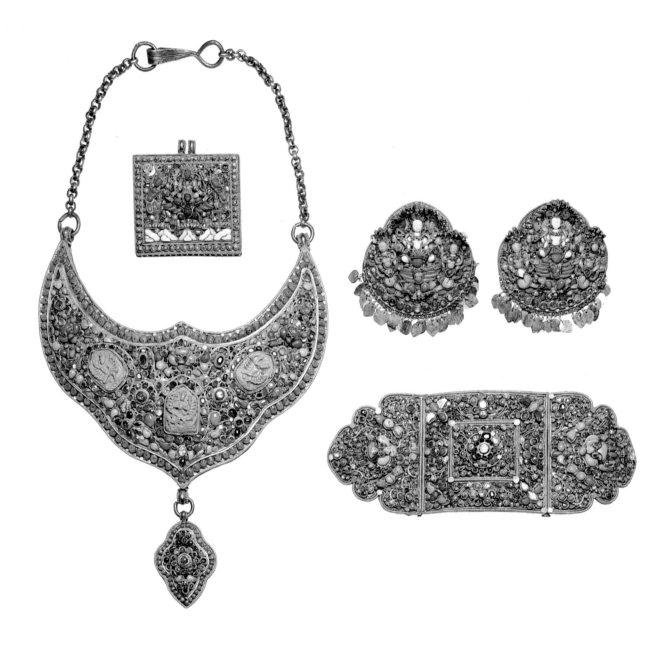

Fig. 33. Ceremonial regalia including necklace, earrings, brooch, and amulet box. Gilt silver with semi-precious stones. Late eighteenth century, Nepal. Asian Art Museum of San Francisco, The Avery Brundage Collection.

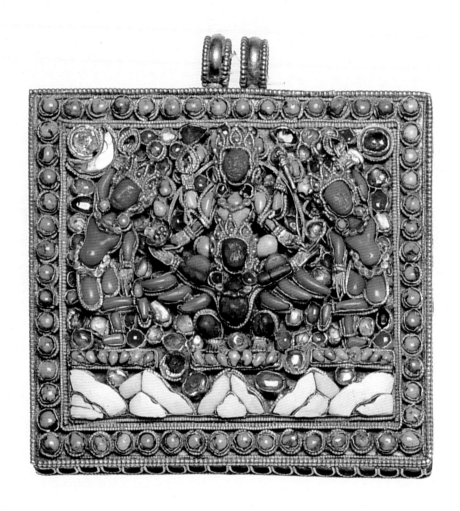

Fig. 34. Amulet box, detail of fig. 33.

The Evolution of Jewelry Forms

The evolution of Tibetan jewelry forms is a fascinating, but little studied area of research.[83] Tibetan statues sometimes bear gold jewelry of some antiquity, and a close examination of such examples may eventually shed light on the evolution of jewelry.[84] Insight into the relationship between the earring and the ear pendant comes from the Mongolian anthropologist Martha Boyer, who did fieldwork during the early part of this century.[85] Boyer observed that one type of Mongol ear ornament was not worn in the ear, but was appended near the ears to frame the face. She had already noted that Mongolian women wore very heavy earrings, and that many of the older women had badly torn earlobes. Boyer deduced that the competitive drive for ever more ornate earrings eventually made some earrings too heavy to be borne by the earlobes. Because they are supported by other devices (e.g., a headdress or other structures), ear pendants could be larger and heavier than earrings while serving the same purpose of demonstrating personal wealth, social status, and enhancing personal attractiveness. At about the same time, Schuyler Cammann came to a similar conclusion.[86] It is likely that Tibetan women's ear pendants (nos. 48-50) followed a similar evolution.

The Iconography on Amulet Boxes

It has already been noted that many of the amulet boxes in this catalogue were made for the Nepalese, evidenced by their Hindu iconography but also by the shape of the cases and the design motifs which they bear. A late 18th century Nepalese jewelry set, now in the Asian Art Museum of San Francisco, includes a thin, square amulet box rendered in gilt silver but otherwise similar in design to the amulet boxes in nos. 1-9, 11, 12, and 14 (figs. 33-34). The San Francisco set's liberal use of inset gems is also reminiscent of many of the works reproduced here. As mentioned above, these amulet cases are probably Nepalese, but they may have been worn by Newars in Tibet. Amulet cases more typically Tibetan include those in nos. 16-19, 25, 28, 29, and 51, 53-56.

The iconography on these amulet boxes is consistent with the aims of the amulets contained within. Gaṇeśa (no. 1) is the Hindu god who helps the faithful overcome obstacles and is generally associated with auspicious beginnings. Durgā Mahiṣāsuramardinī ("The Goddess slaying the Buffalo demon") (nos. 2, 3, 7, 8) is the immensely powerful Hindu goddess portrayed in the act of slaying a buffalo demon. Her awesome strength derives from the rare cooperation of all the gods, who lent her their own implements so that she might slay Mahiṣāsura, who threatened the world in his form as a buffalo demon. Durgā is thought to protect her devotees from disease.

As the personification of the bodhisattva's compassion, Avalokiteśvara assumes an auspicious one hundred and eight forms to respond to the needs of his devotees. His form as Siṁhanāda Lokeśvara (no. 4) was considered particularly effective in curing disease.[87] Avalokiteśvara's ability to save his devotees from peril is described at length in the Lotus Sūtra, a few passages from which are cited below:

"If one be thrown into a pit of fire, by a wicked enemy ... [intent on murder], he has but to think of Avalokiteśvara, and the fire shall be quenched as if sprinkled with water.

If rocks of thunderstone and thunderbolts are thrown at a man's head to kill him, he has but to think of Avalokiteśvara, and they shall not be able to hurt one hair on his body.

If a man be surrounded by a host of enemies armed with swords, who have the intention of killing him, he has but to think of Avalokiteśvara, and they shall instantaneously become kind-hearted.

Mighty spells, witchcraft, herbs, ghosts, and spectres, pernicious to life, revert thither whence they come, when one thinks of Avalokiteśvara.

He [Avalokiteśvara] with his powerful knowledge beholds all creatures who are beset with many hundreds of troubles and afflicted by many sorrows, and thereby is a saviour of the world, including the gods ... "[88]

The five buddhas (no. 11) represent the celestial aspects of the historical Buddha and his various powers: Ratnasambhava ("The Jewel Born"), Amitābha ("He of Boundless Light"), Amoghasiddhi ("He of Infallible Power"), Akṣobhya ("The Unshakable"), and Vairocana ("The Illuminator"). Together, they form a sacred assembly, powerful and profoundly auspicious. Vajrasattva (no. 14) is a Tantric Buddhist deity who assists sentient beings along the path to full enlightenment. The amulet boxes in nos. 51 and 53-56 are without obvious symbolism, although their designs rely on notions of harmony and symmetry, which inform so much of Tibetan art. The amulet box in no. 56 retains some of the original necklaces and clasps by which it was secured around a woman's neck and attached to her clothing.

Fig. 35. Tibetan women gather for a party, Lhasa, ca. 1936–37. Lavish amulet boxes are worn by these wealthy aristocratic women. The brightly colored aprons indicate their status as married women. Photograph by Frederick Spencer Chapman.

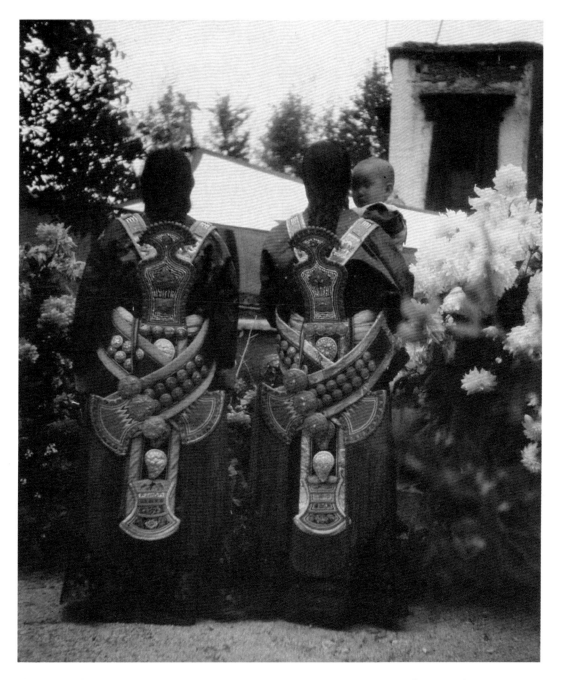

Fig. 36. The fourteenth Dalai Lama's mother and sister adorned in jewelry typical of eastern Tibet, ca. 1936–37. Photograph by Frederick Spencer Chapman.

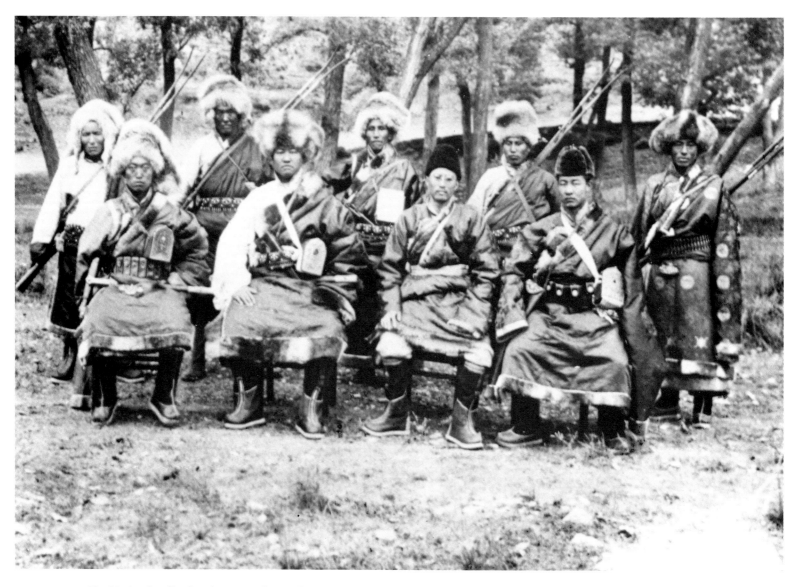

Fig. 37. Amdo officials, Labrang, northeast Tibet, ca. 1930. Photograph by M.G. Griebenow.
Collection of The Newark Museum Tibetan Archive, no. H-3-G. Note the portable shrines worn on their torsos.

The Himalyan Amulet

Amulets exist in all cultures and in all periods. They are meant to ensure auspiciousness, to promote the fulfillment of aspirations, and to protect from harm. They can consist of cloth fragments from a saint, soil from a hallowed site, or any material upon which sacred prayers (*mantra*) are inscribed. In Tibet, amulets of the poor and the rich differ primarily in the materials from which they are made. A poor person might secure an amulet on his or her body with leather straps; the wealthy would encase it in gold, studded with precious gems.

Amulets are most likely to be employed where fear and superstition flourish. Even in modern times and amongst the most educated, fear and superstition were powerful motives in Tibet. Heinrich Harrer describes the effects of superstition on something as apparently straightforward as the introduction of foreign sports in Lhasa in the 1940s:

> "Some years before, we heard, there had been a football ground in the town. Eleven teams were formed and cup–tie matches organised. One day during a match a hailstorm occurred and did a lot of damage, as a result of which football was forbidden. Perhaps the Regent disapproved of the sport and most likely it was thought to be a threat to the influence of the Church, for the people were enthusiastic about the game and many monks from Sera and Drepung were to be found watching the matches. Anyhow the hailstorm was interpreted as a sign that the gods disapproved of this frivolous sport, and football was abolished."[89]

The great Tibetan encyclopedist, Kongtrul Lodro Thaye (t. *kong-sprul blo-gros mtha'-yas*, 1813-99), compiled a collection of amulets which are astonishing in their range and specificity.[90] There are amulets to be worn while committing a robbery; amulets to be worn in battle; amulets to protect the wearer from gossip, to ensure success in business, and to solve family quarrels. Amulets can increase fertility or inhibit conception. They may enhance one's popularity, and protect against epidemics. All these themes associated with amulets spring from a fundamental concern about human suffering and, in particular, how to avoid it.

Buddhism directly addresses the question of human suffering. The recognition that to live is to know suffering informs the first of the historical Buddha's four noble truths: life is suffering (*duḥkha*). Śākyamuni went on to state that suffering has a cause - craving or desire; that suffering can be extinguished; and that there is an eight-fold path to suffering's cessation. The eightfold path involves cultivation of spirituality through right or appropriate views, aspirations, speech, action, livelihood, effort, mindfulness, and concentration. These are sometimes summarized as moral integrity, concentration or meditation, and wisdom.

Śākyamuni, then, taught that suffering could only be completely extinguished by the attainment of spiritual enlightenment. But the quest for spiritual enlightenment is not immediately appealing to all men. A less radical approach to suffering and its cessation is found in the theory of *karma*, shared by Hindus and Buddhists alike. This theory describes some of the ways in which man brings suffering upon himself and, by extension, how to lessen suffering by curtailing the behaviour and attitudes which

are its cause. If we suffer now because of previous ill deeds, we can ensure greater future happiness by performing good deeds in the present. The law of karma includes but is not restricted to one's actions. Karmic effects are generated by the body (i.e., one's actions), speech (all verbal utterances), and mind (all thoughts and emotional inclinations). Key to the fruits of our actions lies is our motivation, as explained by the Tibetan Buddhist teacher, Gampopa (1079-1153). One can kill to obtain an animal's meat or skin; one can kill for sport, for self-protection or for protection of one's friends. One can kill animals in the course of religious sacrifices; one can kill a man out of hatred. Thus, the taking of life brings very different karmic results, depending on our motivation.[91]

L A Waddell, who traveled to Tibet in the late nineteenth century, noted the widespread popularity of the theory of karma, as well as its frequent misinterpretation:

> "Even practices which are clearly dishonest and sinful, are at times justified on the same principle [of karma], or rather by its abuse. Thus the more sordid Tibetan reconciles cheating to his conscience, by naively convincing himself that the party whom he now attempts to defraud, had previously swindled him in a former life, and that justice demands retribution. [92]

Moreover, life's injustices and inequities can be coldheartedly dismissed by reference to this theory: "Congenital defects such as blindness, dumbness and lameness, and accidents, are viewed as retributions which are due to the individual having, in a previous life, abused or sinned with the particular limb or organ presently affected." [93]

When properly interpreted, the theory of karma encourages an individual to assume responsibility for his own life. But beyond cultivating the seeds of future happiness, this theory does not immediately satisfy the yearning for relief from suffering. Moreover, experience shows and Buddhist philosophy allows that there are spheres and forces beyond our control, which nevertheless have enormous impact on our lives. Amulets attempt to influence these spheres and to assuage these forces.

★

Tibetans retain much of their pre-Buddhist animist worldview. All nature is alive with power, controlled by countless low-level demons, some of whom are benevolent, others of whom are malevolent and others still who are indifferent but can be influenced by men towards benevolent or malevolent deeds. Many amulets in Kongtrul's account have to do with pacifying these potentially harmful demons.[94] Deities reside in the sky, in glaciers, in rocks and mountain passes. One group of deities (t. *the'u-rang*) live in the lower regions of the sky. They are "of evil nature, cause quarrels, disunity, bring premature death, harm children and influence the weather." [95] Other deities are more benevolent in nature, e.g., the *lha*, who watch over specific realms of experience such as the hearth (t. *thab-lha*), the path (t. *lam-lha*), and trade (t. *tshong-lha*).[96] Malevolent spirits known as *'dre* spread mortal diseases and cause sudden death. Some deities are whimsical in nature, such as the *sa-bdag* ("masters of the soil") who, according to Tadeusz Skorupski, "are considered to be of indifferent nature but can be good or bad

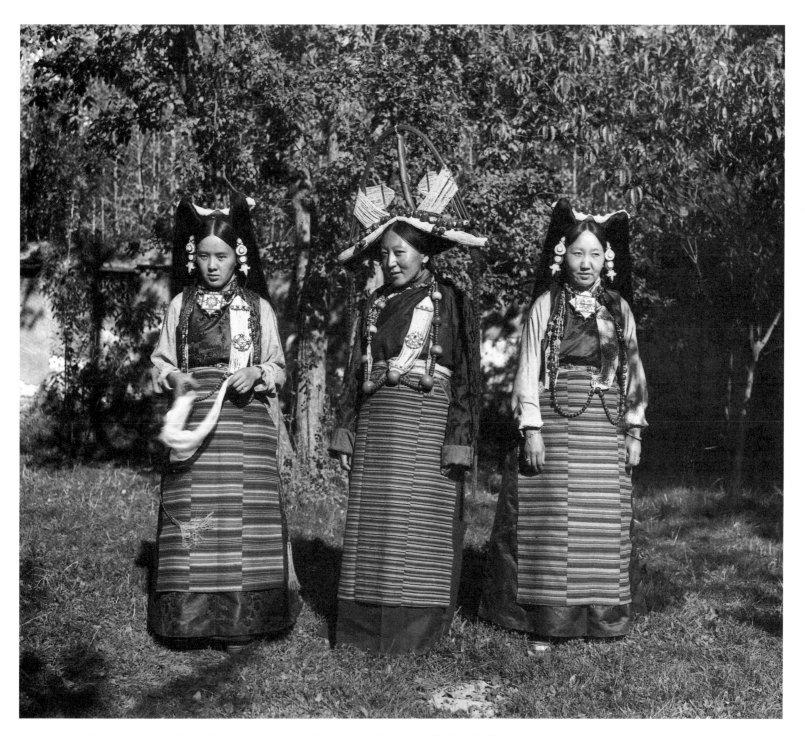

Fig. 38. Rinchen Dolma Taring, Mrs. Pema Dolkar Tsarong, Mrs. Tseten Dolkar Horkhang.
Lhasa, 1937, photograph by C. Suydam Cutting. Collection of The Newark Museum Tibetan Archives, no. I–86–C.

51

depending on whether they are placated or offended." [97] Tucci describes many deities as " ... vague forces and entities, of whose power and agency men are greatly afraid ... even a peaceful deity, on account of some involuntary distraction of the believer, turns harmful ... "[98]

Illness is a powerful area of concern and a large group of amulets promise protection from the demons who cause disease. Medical diagnosis in Tibet was conducted by lamas who relied on a veritable cornucopia of remedies, amulets among them. In the Tibetan theory of medicine, disease is multi-determined, with demonic influences commonly cited among the causes of disease. [99] Thus, oral diseases can be caused by improper diet, poor conduct, and demonic influences. [100] Madness may be caused by "feeble stamina, grief, unhappiness, incompatible diet and conduct, and the harmful influence of demons. [101] There are male, female, and neuter demons who cause disease; there are both strong and weak congenital demons who perpetuate the effect of past karma; there are strong and weak demons of the imagination who affect disease. Specific demons are associated with disease among children, the elderly, and those in their prime. Amulets exist for all these circumstances. But demons cannot always be assuaged, just as diseases cannot always be cured; one might be tempted to see a link between the two.

The essential power of an amulet lies in the sacred sounds (*mantra*) inscribed upon it. The amulet is effective after consecration, when a deity is summoned and invited to enter into the amulet's mantras. Amulet boxes are sometimes hung on sacred images from which they derive additional power before they are retrieved and worn by their owners (fig. 39). But lamas admit that "amulets can only bring the desired result when a person has the right inner disposition and firm conviction that they have the magical power to protect." [102]

Tibetan belief in the power of amulets was never more poignantly demonstrated than when Tibetans, armed with amulets and guns, entered into battle with British troops during the Younghusband expedition of 1904. They were badly beaten. An eyewitness and correspondent for the *Daily Mail*, Edmund Candler recorded what he saw:

> "As my wounds were being dressed I peered over the mount at the rout. They were walking away! Why ... did they not run? There was cover behind a bend in a hill a few hundred yards distant, and [the Tibetans] were exposed to a devastating hail of bullets from the Maxims and rifles, that seemed to mow down every third or fourth man. Yet they walked! ... Prayers, and charms, and mantras, and the holiest of their holy men, had failed them ... They walked with bowed heads, as if they had been disillusioned in their gods." [103]

But accounts of the effectiveness of amulets abound. Ekai Kawaguchi describes an attempt on the life of the thirteenth Dalai Lama in 1901. The perpetrators placed destructive amulets in the soles of footwear which they presented to the Dalai Lama. The Dalai Lama fell ill each time he wore them, and his attentive advisors eventually saw a causal link between his illness and the shoes. The amulet was found and confiscated, and the criminals were captured and punished. [104]

It could be said that in trying to shield men from pain, amulets attempt the impossible. Grief, uncertainty, and unfulfilled desires are common threads in all lives. Human greatness lies in the willingness to accept suffering (both that of our own creation and that fully beyond our control), the courage to learn from it, and the strength to continue to manifest the higher human attributes – defined in the Tibetan Buddhist tradition as compassion, insight, and wisdom. Without fear, there is no opportunity to express courage; without powerful desires, no opportunity to develop balance and wise restraint; without deprivation, no opportunity for true generosity. Whether encased in gold or roughly tied against naked skin, an amulet's magic lies in its ability to temporarily allay our fears. In so far as it enhances courage, the amulet may be described as effective, for in the final analysis, a courageous heart is the truest talisman at man's disposal.

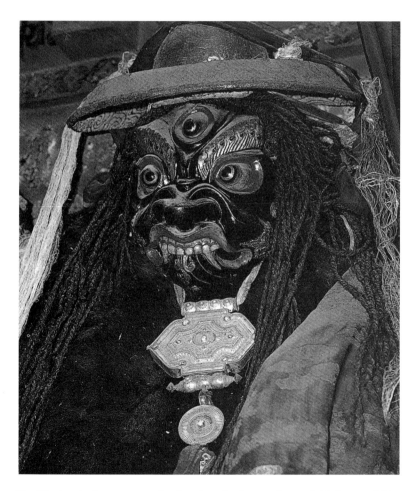

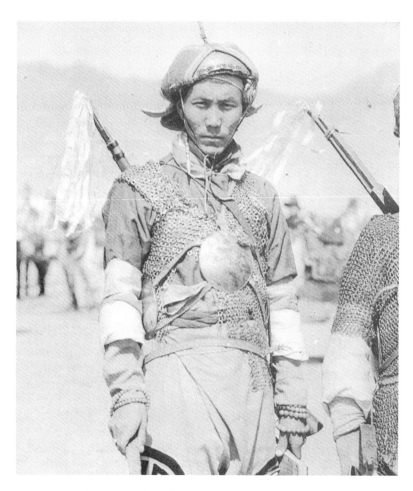

Fig. 39. Amulet box temporarily placed on the image of a wrathful deity, Ladakh. Amulet boxes are sometimes hung on sacred images from which they derive additional power before they are retrieved by their owners.

Fig. 40. Armed Tibetan soldier, Lhasa, ca. 1936. Note the amulet box tucked inside his helmet and prayer beads around each wrist. Photograph by Hugh Richardson.

1. Very little ancient gold jewelry survives from Tibet. Its rarity may stem from a practice described by the Lhasa aristocrat, Dorje Yudon Yuthok (1912-), who noted the tendency in her day to recycle jewelry, reusing the inset gems in new creations which reflected changing fashions. See Dorje Yudon Yuthok, *House of the Turquoise Roof* (New York: Snow Lions Publications, 1990), pp. 187-88.

2. This is true despite important contributions in works such as Stephanie and Ghislaine zu Windische-Graetz, *Juwelen des Himalaja* (Luzern: Reich, 1981) and Hans Weihreter, *Schmuck aus dem Himalaja* (Graz: Akademische Druck- u. Verlagsanstalt, 1988). Tibetans generally refrain from disturbing the soil, although the Chinese have recently begun to excavate in Tibet. Earlier archaeological reports are scant. Heinrich Harrer wrote that while excavating to build canals just outside of Lhasa in the 1940s, Peter Aufschnaiter found graves "thousands of years old." Carefully preserved skeletons were buried with bowls and semiprecious gems. Harrer noted that "None of the Lamas whom [Aufschnaiter] consulted could throw light on his finds, and there was no mention in the old history books of an epoch in which the Tibetans used to bury their dead and put gifts in their graves." Heinrich Harrer, *Seven Years in Tibet* (London: Rupert Hart-Davis, 1953), pp. 227-28.

3. See for example Julia M. White and Emma C. Bunker, *Adornment for Eternity: Status and Rank in Chinese Ornament* (Denver: Denver Art Museum, 1994).

4. See Herbert V. Guenther, trans., *Jewel Ornament of Liberation* (London: Rider & Company, 1959).

5. H. Kern, trans., *Saddharma-Puṇḍarīka or The Lotus of the True Law* (Oxford: Clarendon Press, 1884; reprint New York: Dover Publications, Inc., 1963), p. 66.

6. Ananda K. Coomaraswamy, "Ornament" in Roger Lipsey, ed. *Coomaraswamy: Selected Papers* (Princeton: Princeton University Press, 1977) vol. 1, p. 243. The Tibetan term for ornament and jewelry, *gyen* (*rgyan*), is a translation of the Sanskrit word, *alaṃkāra*. See Lokesh Chandra, *Tibetan-Sanskrit Dictionary* (Tokyo: Rinsen Book Co., 1990).

7. Patricia Berger, review of *Adornment for Eternity: Status and Rank in Chinese Ornament*, in *Orientations* 26, no. 5 (May 1995), p. 78.

8. Sometimes people and their gods shared the same jewelry. In her autobiography, Dorje Yudon Yuthok (1912-) describes statues in her home chapel as "dressed in brocade robes and wearing full sets of our best family jewelry." *House of the Turquoise Roof*, p. 67.

9. L. Austine Waddell, *Tibetan Buddhism: With its Mystic Cults, Symbolism and Mythology* (London: W.H. Allen & Co., 1895; reprint edition New York: Dover Publications, Inc., 1972), p. 210. The Panchen Lama, head of Tashilunpo monastery, is widely considered the second highest ranking lama in Tibet after the Dalai Lama. The historian Phuntsok Tashi Takla, however, found it highly unlikely that the Panchen Lama (or any other monastic) wore any form of jewelry other than an amulet box. (Personal communication, London, September 1995.)

10. K.C. Pandey, *Abhinavagupta: An Historical and Philosophical Study* (Varanasi: Chowkhamba Sanskrit Series Office, 1963), p. 621.

11. Pandey, *Abhinavagupta*, pp. 648-49.

12. E.H. Johnston, trans., *The Buddhacarita*, 2 vols. (Calcutta: Baptist Mission Press, 1936), vol. 2, pp. 82-83.

13. See Paul Mus, "Le Bouddha Paré. Son origine indienne. Śākyamuni dans le Mahāyānisme moyen," *Bulletin de l'école Française d'Extrême-Orient* 28 (1928): 147-278.

14. Indian treatises on iconography, such as *The Mahāvastu*, describe thirty-two great marks (*mahāpuruṣalakṣaṇa*) of the enlightened being, as well as an additional eighty lesser marks (*anuvyañjanalaksana*).

15. J.J. Jones, trans., *The Mahāvastu* (London: Luzac & Co., 1956), vol. 3, pp. 262-64.

16. Jones, *The Mahāvastu*, vol. 3, pp. 412-13.

17. Harrer, *Seven Years in Tibet*, p. 236.

18. Harrer, *Seven Years in Tibet*, p. 175.

19. Valrae Reynolds, *Tibet: A Lost World* (New York: The American Federation of Arts, 1978), p. 40, n.1.

20. Hugh Richardson, *Ceremonies of the Lhasa Year* (London: Serindia Publications, 1993), p. 22. For a description of the various types of women's headdresses and other jewelry, see Yuthok, *House of the Turquoise Roof*, pp. 185-94; 321-25.

21. Harrer, *Seven Years in Tibet*, p. 121.

22. Heinrich Harrer, "My Life in Forbidden Lhasa," *The National Geographic Magazine* CVIII, no. 1 (July, 1955): 1-48, p. 15.

23. Yuthok, *House of the Turquoise Roof*, p. 189.

24. Yuthok, *House of the Turquoise Roof*, p. 190.

25. Harrer, "My Life in Forbidden Lhasa," p. 27.

26. Charles Bell, *The Religion of Tibet* (Oxford: Oxford University Press, 1931), p. 175. Mr. Takla confirms this estimate, but mentioned a group of approximately 200 lay clerks who were outside the ranking system but performed tasks crucial to the civil service.

27. The following description of the Tibetan government structure largely derives from discussions with the historian Phuntsok Tashi Takla, himself a retired army general of the fourth rank. It also derives from Tsepon Shakabpa, *Tibet: A Political History* (New Haven: Yale University Press, 1967; reprint New York: Potala Publications, 1984; page references to reprint edition), pp. 21-22.

28. Mr. Takla recalled that all four ministers were laymen, but Shakabpa states there were three laymen and one monk. (See Shakabpa, *Tibet: A Political History*, p. 21.) Takla noted that the Dalai Lama's father was also entitled to wear a hat of the second rank and that a few deputy ministers were appointed to the second rank when required.

29. According to Mr. Takla, the third rank also included many honorary posts.

30. A similar finial, consisting of a vase with overflowing water marked by pearls, is now in the Newark Museum collection and once belonged to the Tibetan Finance Minister, Shakabpa. See Reynolds, *Tibet: A Lost World*, p. 45.

31 Richardson, *Ceremonies of the Lhasa Year*, pp. 30, 82.

32 Mr. Takla points out that others (e.g., postmen, undertakers, servants of nobility) could also wear this earring, although normally their earrings were made of brass.

33 According to Eleanor Olson, *Catalogue of the Tibetan Collection and other Lamaist articles in The Newark Museum*, volumes I-V (Newark: Newark Museum, 1950-1971, reprint 1971-1975; page references to reprint editions), vol. IV, p. 57. Mr. Takla, however, recalled that members of any rank could wear these amulets in their braided hair, although only those of the fourth rank and above could secure their braids at the top of their heads. Harrer had also noted that only higher ranking lay government officials could fix their braids at the top of their heads, although he did not specify which ranks. See Heinrich Harrer, "My Life in Forbidden Lhasa," caption to photograph on p. 5.

34 Mr. Takla noted that these ornaments were owned by the government. They were lent to officials of the fourth and fifth ranks for important processions such as the New Year ceremonies, and for ceremonies to greet the Dalai Lama returning to Lhasa.

35 Harrer, "My Life in Forbidden Lhasa," p. 18.

36 Richardson, *Ceremonies of the Lhasa Year*, pp. 15-16.

37 See Olson, *Catalogue of the Tibetan Collection* IV, pl. XXXII, no. 6, p. 102. See the same vol. p. 62, where she notes that "Holton describes this as a single earring which may be worn by either a man or a woman." For photographs of women wearing pairs of this type of earring (as in no. 33 in this volume), see Charles Bell, *The Religion of Tibet*, picture facing p. 120. Men normally wear one pendant earring in their left ears and a turquoise stud in the right.

38 Bell, *The People of Tibet*, p. 180.

39 Liu Lizhong states "the corpse was preserved by careful drying and embalming with oils and scents," suggesting that the tomb has been opened since the Chinese occupation. See his *Buddhist Art of the Tibetan Plateau* (Hong Kong: Joint Publishing Co., Ltd., 1989), p. 247. Elsewhere in the Potala are tombs of other Dalai Lamas.

40 Liu, *Buddhist Art of the Tibetan Plateau*, p. 247.

41 The Panchen Lama's tomb at Tashilungpo monastery and other revered teachers' tombs also bear personal ornaments, suggesting this custom was associated with the burial of other high ranking Buddhists in Tibet.

42 Mr. Takla stressed that these ornaments were not specifically made for this purpose; they were personal ornaments donated to the Dalai Lama either during his lifetime or on the occasion of his death.

43 Kern, *The Lotus Sūtra*, p. 412.

44 Gregory Schopen, "Burial 'ad sanctos' and the Physical Presence of the Buddha in Early Indian Buddhism," *Religion* (1987) 17: 193-225.

45 Susan Stronge, Nima Smith and J.C. Harle, *A Golden Treasury: Jewellry from the Indian Subcontinent* (London and Ahmedabad, V&A and Mapin Publishing Pvt. Ltd., 1988), pp. 20-21, no. 18.

46 Schopen, "Burial 'ad sanctos' and the Physical Presence of the Buddha in Early Indian Buddhism," p. 202. Schopen quotes U.A. Casal, " The Saintly Kōbō Daishi in Popular Lore (A.D. 774-835)," *Journal of Far Eastern Folklore. Folklore Studies*, 19 (1959), p. 143.

47 Gold deposits have been identified in the *byang-thang* region in northern Tibet, as well as in the south, northeast, and southeastern regions. See *Ancient Tibet: Research Materials* (Berkeley, Ca.: Dharma Publishing, 1986), pp. 55-63.

48 Martha Boyer, *Mongol Jewellery* (Copenhagen: Kommission hos Gyldendalske Godhandel, Nordisk Forlag, 1952), p. 169.

49 David MacDonald, *The Land of the Lhama* (London: Seeley, Service and Co., Ltd., 1929), p. 25.

50 Yuthok states that although gold is found in many parts of Tibet, demand was greater than the local supply obtained by mining; "[v]ery often gold had to be imported from India and China." *House of the Turquoise Roof*, p. 191.

51 William of Rubruck, *The Journey of William of Rubruck to the Eastern Parts of the World 1253-1255 as narrated by himself*, ed. W.W. Rockhill (London: Hakluyt Society Series, 2-3, 1900), p. 152. As quoted in Olson, *Catalogue of the Tibetan Collection*, vol. IV, p. 54.

52 W.W. Rockhill, *Diary of a Journey through Mongolia and Tibet in 1891 and 1892*. Smithsonian Institute, Washington, D.C., 1894, pp. 360-61. Cited in Olson, *Catalogue of the Tibetan Collection*, vol. IV, p. 54.

53 Edward H. Schafer, *The Golden Peaches of Samarkand* (Berkeley: University of California Press, 1985), p. 254.

54 Schafer, *The Golden Peaches of Samarkand*, p. 254.

55 Schafer, *The Golden Peaches of Samarkand*, p. 254.

56 Schafer, *The Golden Peaches of Samarkand*, p. 254; Boyer, *Mongol Jewellery*, p. 175.

57 Ariane MacDonald, "Une lecture des P.T. 1286, 1287, 1038, 1047 et 1290. Essai sur la formation et l'emploi des mythes politiques dans la religion royale de Srong-btsan sgam-po," in A. MacDonald, ed. *Études tibetaines dediées à la memoire de Marcelle Lalou* (Paris: Librairie d'Amérique et d'Orient, 1971), pp. 232, 305.

58 Erik Haarh, *The Yar-lun Dynasty* (Copenhagen: G.E.C. Gad's Forlag, 1969), p. 346.

59 This translation appears in David Snellgrove and Hugh Richardson, *A Cultural History of Tibet* (Boulder: Prajna Press, 1980), p. 52. Haarh also translates portions of the same document in *The Yar-lun Dynasty*, p. 350.

60 See Paola Mortari Vergara Caffarelli, "Architectural Style in the Tibetan Tombs from the Period of the Kings," in Jane Casey Singer and Philip Denwood, eds., *Tibetan Art : Towards a Definition of Style*. (London: Calmann and King Ltd. in association with Alan Marcuson, forthcoming 1997).

61 Olson, *Catalogue of the Tibetan Collection*, vol. IV, p. 52. See also B. Laufer, *Notes on Turquois in the East*. Field Museum of Natural History, Pub. no. 169, Anthropological series, vol. XIII, no. 1. Chicago, 1913.

62 Berthold Laufer noted that the turquoise mosaic technique may hark back to Siberian bronze age jewelry. See Laufer, "Notes on Turquois in the East," p. 15, n. 4.

63 Col Sir Henry Yule, tr. and ed., *The Book of Ser Marco Polo*, 3rd ed. (London: John Murray, 1903), vol. II, p. 49.

64 Schafer, *The Golden Peaches of Samarkand*, p. 232. Cf. the turquoise and gold hair ornaments (no. 59 and fig. 21) in this volume.

65 Yuri Parfionovitch, Gyurme Dorje and Fernand Meyer, *Tibetan Medical Paintings*, 2 vols. (London: Serindia Publications, 1992) vol. 1, p. 61.

66 Parfionovitch et al., *Tibetan Medical Paintings*, p. 61.

67 Parfionovitch et al., *Tibetan Medical Paintings*, p. 61.

68 For a history of Newar craftsmen and their association with Tibet, see Erberto LoBue, "The Newar Artists of the Nepal Valley. An Historical Account of Their Activities in neighbouring Areas with Particular Reference to Tibet," 2 parts in *Oriental Art* vol. 31, no. 3 (Autumn 1985): 262-77; and vol. 31, no. 4 (Winter 1985/86): 409-20. See also Olson, *Catalogue of the Tibetan Collection*, vol. IV, p. 53, n. 5.

69 LoBue, "Newar Artists, Part 2," p. 409.

70 See LoBue, "Newar Artists, Part 2," p. 410; and John Clarke, "A Regional Survey and Stylistic Analysis of Tibetan Non-Sculptural Metalworking, c. 1850-1959" (unpublished doctoral dissertation, School of Oriental and African Studies, London University, 1995), p. 34. According to Yuthok, Lhasa's population was about 20,000 before the Chinese invasion. (*House of the Turquoise Roof*, p. 201.) Perhaps one half of Lhasa's population consisted of monks living in Tibet's three largest monasteries - Drepung, Ganden, and Sera.

71 Clarke, "Regional Survey of Tibetan Metalwork," p. 112. Yuthok describes goldsmiths who came to her Lhasa home to carry out her jewelry commissions. See *House of the Turquoise Roof*, pp. 190-91.

72 The etymology of *kaccara* is described in Erberto LoBue, "Himalayan Sculpture in the 20th Century: A Study of the Religious Statuary in Metal and Clay of the Nepal Valley and Ladakh." Ph.D. dissertation, School of Oriental and African Studies, London University, 1981, pp. 25-26.

73 Charles Bell, *Tibet Past and Present* (Oxford: Oxford University Press, 1924), p. 233. As cited in Clarke, "Regional Survey of Tibetan Metalwork," p. 119.

74 Clarke, "Regional Survey of Tibetan Metalwork," p. 120.

75 This notion is supported by the fact that the amulets in nos. 10-13, all adorned with Buddhist iconography, are in the Indian *devanāgarī* script, mixed with Newari characters - suggesting they were written by Newars.

76 Ian Alsop, "Repoussé in Nepal," *Orientations* 17, no. 17 (July 1986): 14-27.

77 Compare similar ornaments worn near the ears of government officials in figure 4.

78 This account derives from that in Heinrich Zimmer, *Myths and Symbols in Indian Art and Civilization* (Princeton: Princeton University Press, 1974), pp. 175-82.

79 Zimmer, *Myths and Symbols in Indian Art and Civilization*, pp. 181-82

80 These images also frequently bear horns, the origin of which is unclear.

81 Olson, *Catalogue of the Tibetan Collection*, vol. IV, pp. 42-43.

82 Schuyler Cammann, "Tibetan Monster Masks," *Journal of West China Border Research Society*, Chengtu, Series A (1940: XII), pp. 9-19, fig. 1-8.

83 Some Tibetan women's headdresses resemble horns or antlers and may have ancient roots in Tibetan pre-Buddhist, animist culture. See Martha Boyer's discussion of similar Mongolian headdresses in Boyer, *Mongol Jewellery*, pp. 101-25.

84 Yuthok notes that pieces of gold jewelry which were family heirlooms would sometimes be placed on religious images. See *House of the Turquoise Roof*, p. 188.

85 Boyer, *Mongol Jewellery*, p. 123.

86 Schuyler Cammann, *The Land of the Camel* (New York: The Ronald Press Co., 1951), p. 137.

87 Benoytosh Bhattacharyya, *The Indian Buddhist Iconography* (Calcutta: Firma K.L. Mukhopadhyay, 1968), p. 127.

88 Kern, *The Lotus Sūtra*, pp. 413-16.

89 Harrer, *Seven Years in Tibet*, p. 133.

90 Tadeusz Skorupski, *Tibetan Amulets* (Bangkok, White Orchid Press, 1983). Skorupski's work is drawn from two short works in the *rin-chen gter-mdzod* by Kongtrul.

91 Guenther, trans., *Jewel Ornament of Liberation*, p. 75.

92 Waddell, *Tibetan Buddhism*, p. 567.

93 Waddell, *Tibetan Buddhism*, p. 567.

94 There are many classifications of Tibetan demons. Skorupski discusses some classification systems in *Tibetan Amulets*, pp. 3-7; see also Tucci, *The Religions of Tibet*, pp. 163-212, passim.

95 Skorupski, *Tibetan Amulets*, p. 4.

96 Skorupski, *Tibetan Amulets*, p. 5.

97 Skorupski, *Tibetan Amulets*, p. 5.

98 Tucci, *The Religions of Tibet*, p. 721.

99 See Parfionovitch et al., *Tibetan Medical Paintings*, vol. 1; plates 64-66 are specifically on demonic possession.

100 Parfionovitch et al., *Tibetan Medical Paintings*, vol. 1, p. 101.

101 Parfionovitch et al., *Tibetan Medical Paintings*, vol. 1, p. 107.

102 Skorupski, *Tibetan Amulets*, p. 7.

103 Edmund Candler, *The Unveiling of Lhasa* (London: Thomas Nelson, 1905), pp. 144-45.

104 Ekai Kawaguchi, *Three Years in Tibet* (Madras: The Theosophist Office, 1909), p. 375.

Alsop, Ian. "Repoussé in Nepal," *Orientations* 17, no. 17 (July 1986): 14-27.

Asian Art Museum of San Francisco. *Beauty, Wealth, and Power: Jewels and Ornaments of Asia.* San Francisco: Asian Art Museum, 1992.

Bell, Sir Charles. *The Religion of Tibet.* Oxford: Clarendon Press, 1931; reprint 1970.

Boyer, Martha. *Mongol Jewellery.* Copenhagen: I Kommission Hos Gyldendalske Boghandel, Nordisk Forlag, 1952.

Clarke, John. "A Regional Survey and Stylistic Analysis of Tibetan Non-Sculptural Metalworking, c. 1850-1959" (unpublished doctoral dissertation, School of Oriental and African Studies, London University, 1995).

Coomaraswamy, Ananda K. "Ornament" in Roger Lipsey, ed. *Coomaraswamy: Selected Papers.* Princeton: University Press, 1977. 3 vols., vol. 1, pp. 241-53.

Guenther, Herbert V., trans. *Jewel Ornament of Liberation.* London: Rider & Company, 1959.

Harrer, Heinrich. "My Life in Forbidden Lhasa," *The National Geographic Magazine* 108, no. 1 (July 1955): 1-48.

_____. *Seven Years in Tibet.* London: Rupert Hart-Davis, 1953.

H. Kern, trans. *Saddharma-Puṇḍarīka or The Lotus of the True Law.* Oxford: Clarendon Press, 1884; reprint New York: Dover Publications, Inc., 1963.

Liu, Lizhong. *Buddhist Art of the Tibetan Plateau.* Hong Kong: Joint Publishing Co. Ltd., 1989.

LoBue, Erberto. "The Newar Artists of the Nepal Valley. An Historical Account of their Activities in Neighbouring Areas with Particular Reference to Tibet," *Oriental Art* vol. 31, no. 3 (Autumn 1985): 262-77 and vol. 31, no. 4 (Winter 1985/86): 409-20.

Olson, Eleanor. *Catalogue of the Tibetan Collection and other Lamaist articles in The Newark Museum,* volumes I-V. Newark: Newark Museum, 1950-1971, reprint 1971-1975.

Parfionovitch, Yuri, Gyurme Dorje and Fernand Meyer, *Tibetan Medical Paintings,* 2 vols. London: Serindia Publications, 1992.

Reynolds, Valrae. *Tibet: A Lost World.* New York: The American Federation of Arts, 1978.

_____. "From a Lost World: Tibetan Costumes and Textiles," *Orientations* (March 1981): 6-22.

_____. "Tibetan Jewelry: A Lost Art," *American Craft* (October/November 1981): 30-35.

Richardson, Hugh. *Ceremonies of the Lhasa Year.* London: Serindia Publications, 1993.

Shakabpa, Tsepon. *Tibet: A Political History.* New Haven: Yale University Press, 1967; reprint New York: Potala Publications, 1984.

Skorupski, Tadeusz. *Tibetan Amulets.* Bangkok: White Orchid Press, 1983.

Snellgrove, David. *Indo-Tibetan Buddhism.* London: Serindia, 1987.

Snellgrove, David and Hugh Richardson. *A Cultural History of Tibet.* Boulder: Prajñā Press, 1980.

Tucci, Giuseppe. *The Religions of Tibet.* Translated by Geoffrey Samuel. London: Routledge & Kegan Paul Ltd., 1980.

Waddell, L. Austine. *Tibetan Buddhism: With its Mystic Cults, Symbolism and Mythology.* London: W. H. Allen & Co., 1895; reprint edition New York: Dover Publications, Inc., 1972.

Weihreter, Hans. *Schmuck aus dem Himalaja.* Graz: Akademische Druck-u. Verlagsanstalt, 1988.

White, Julia M. and Emma C. Bunker. *Adornment for Eternity: Status and Rank in Chinese Ornament.* Denver: Denver Art Museum, 1994.

Williams, Paul. *Mahayana Buddhism: The Doctrinal Foundations.* London and New York: Routledge, 1989.

zu Windisch-Graetz, Stephanie and Ghislaine. *Juwelen des Himalaya.* Luzern: Reich, 1981.

Yutok, Dorje Yudon. *House of the Turquoise Roof.* New York: Snow Lion Publications, 1990.

Colour Plates

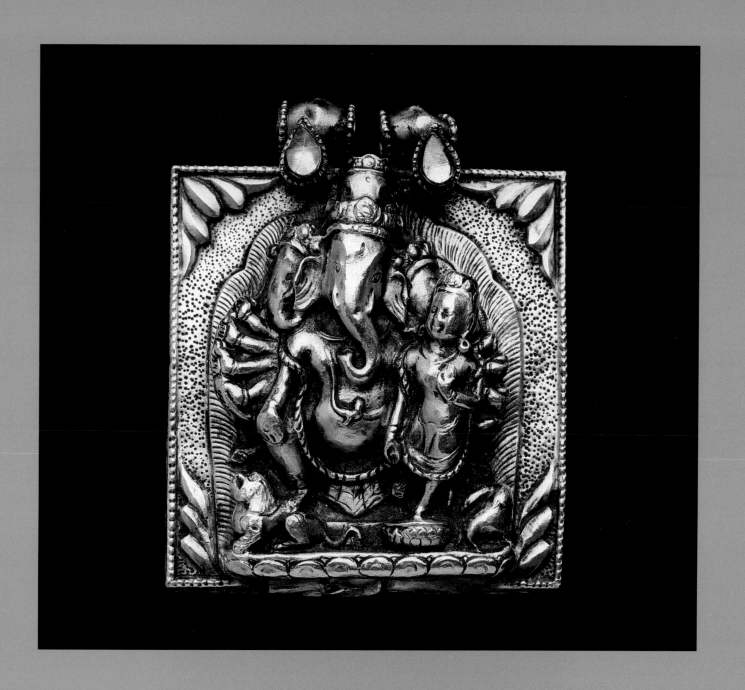

1. Amulet box adorned with Gaṇeśa and consort
Gold repoussé, quartz
H: 7.8 cm; W: 6.2 cm; D: 2.8 cm

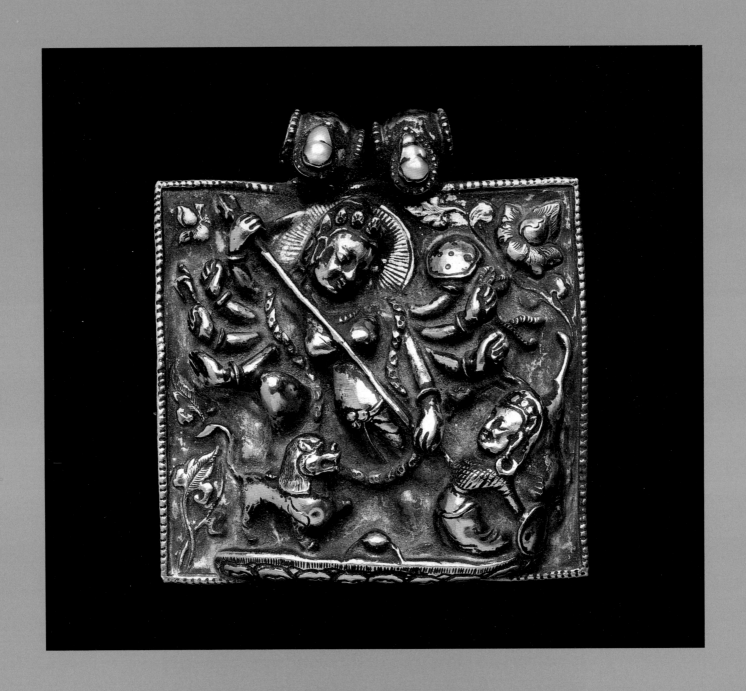

2. Amulet box adorned with Durgā Mahiṣāsuramardinī
Gold repoussé, pearl
H: 7.4; W: 6.7; D: 2.2 cm

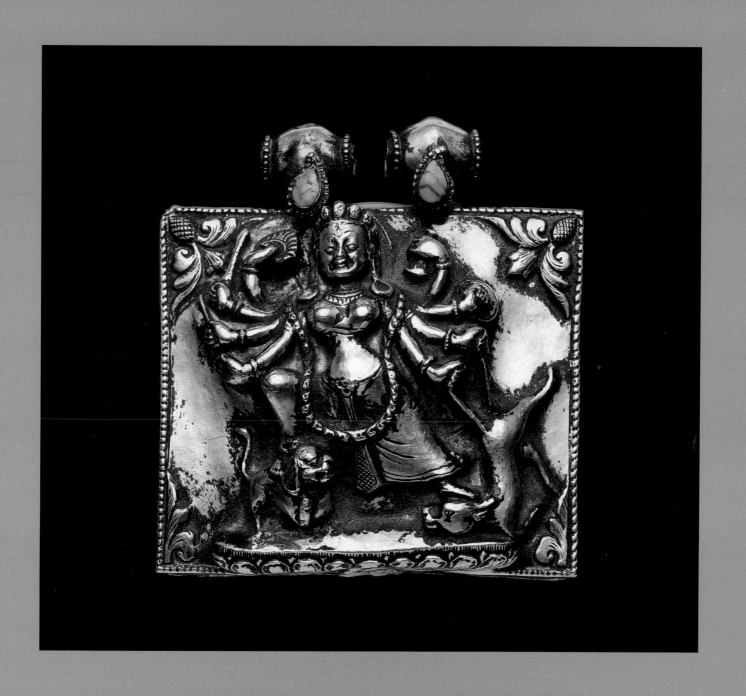

3. Amulet box adorned with Durgā Mahiṣāsuramardinī
Gold repoussé, turquoise
H: 7.5 cm; W: 6.8 cm; D: 2.7 cm

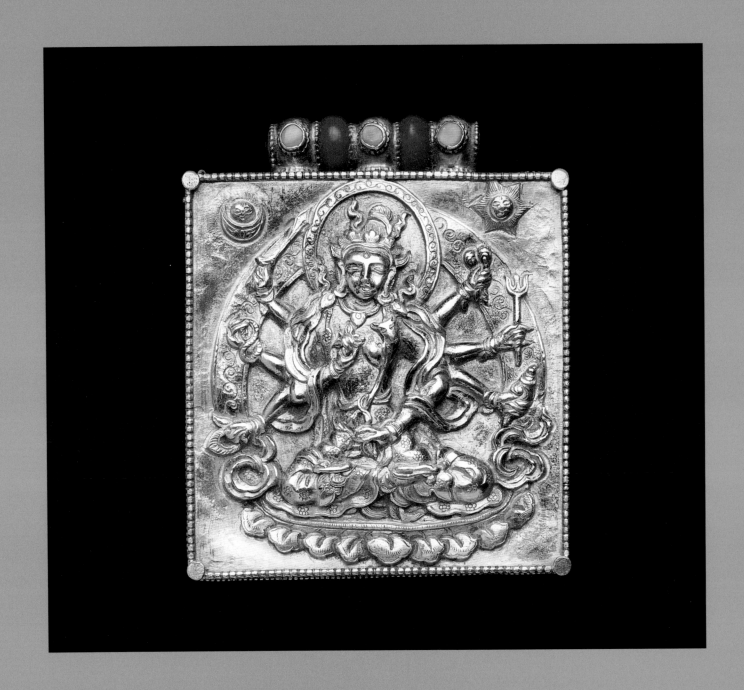

4. Amulet box adorned with Siṁhanāda Avalokiteśvara
Gold repoussé, coral, turquoise
H: 6.9 cm; W: 5.8 cm; D: 1.8 cm

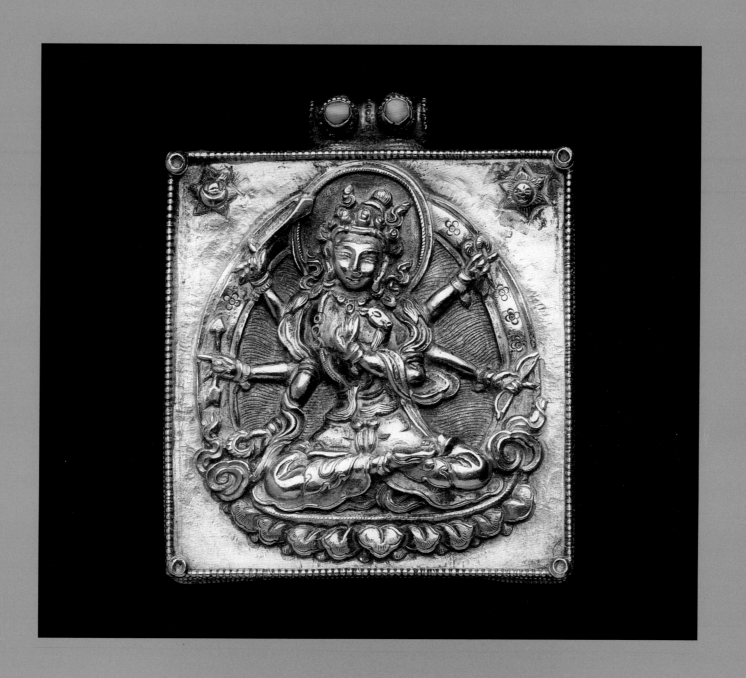

5. Amulet box adorned with Viśvahana Lokeśvara
Gold repoussé, turquoise
H: 6.5 cm; W: 5.5 cm; D: 1.8 cm

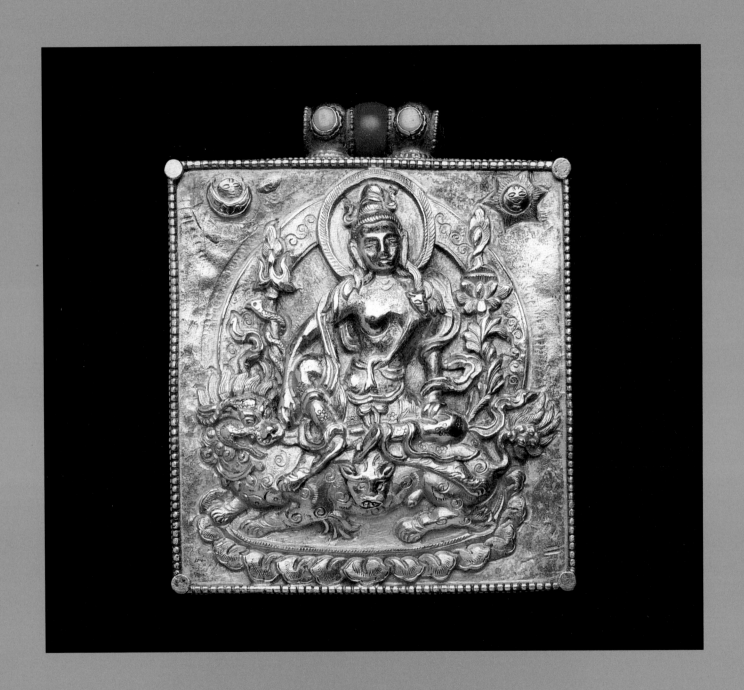

6. Amulet box adorned with Lokeśvara
Gold repoussé, turquoise, coral
H: 6.8 cm; W: 5.6 cm; D: 1.7 cm

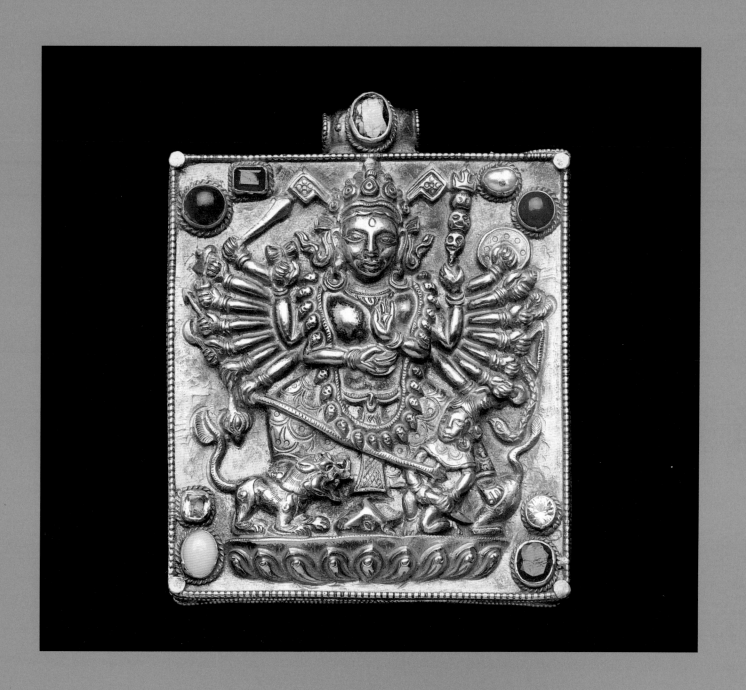

7. Amulet box adorned with Durgā Mahiṣāsuramardinī
Gold repoussé, lapis lazuli, coral, pearl, opal, emerald, ruby, glass
H: 7.8 cm; W: 6.9 cm; D: 1.4 cm

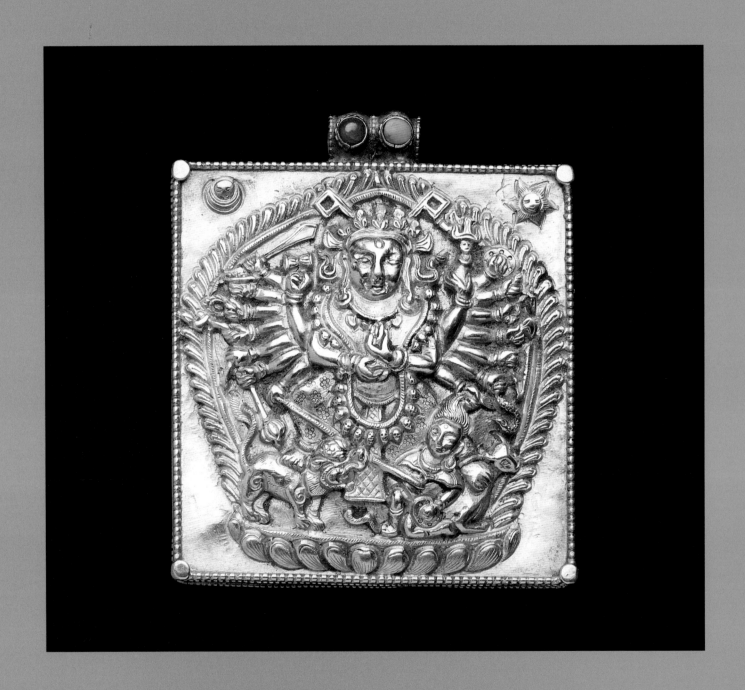

8. Amulet box adorned with Durgā Mahiṣāsuramardinī
Gold repoussé, turquoise, coral
H: 7 cm; W: 6 cm; D: 1.3 cm

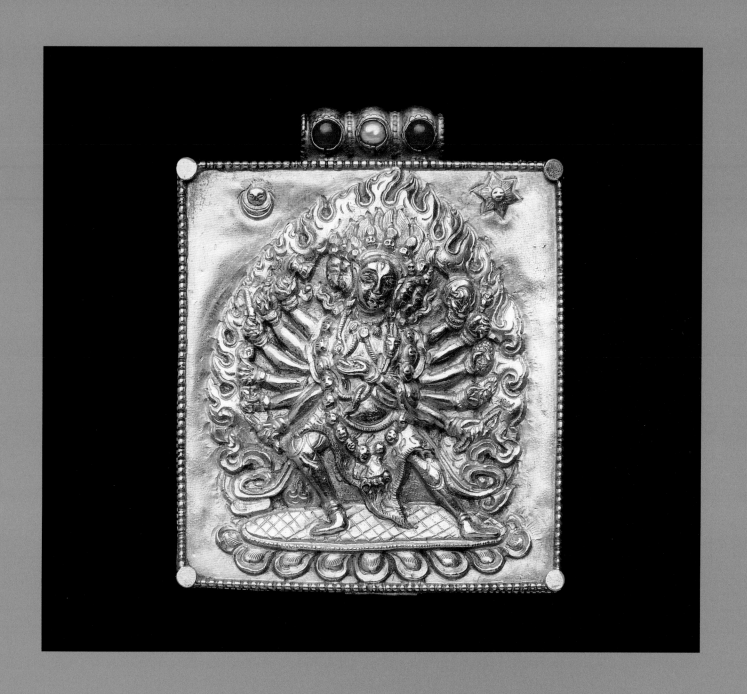

9. Amulet box adorned with wrathful Lokeśvara
Gold repoussé, coral, pearl
H: 7.3 cm; W: 5.8 cm; D: 1.8 cm

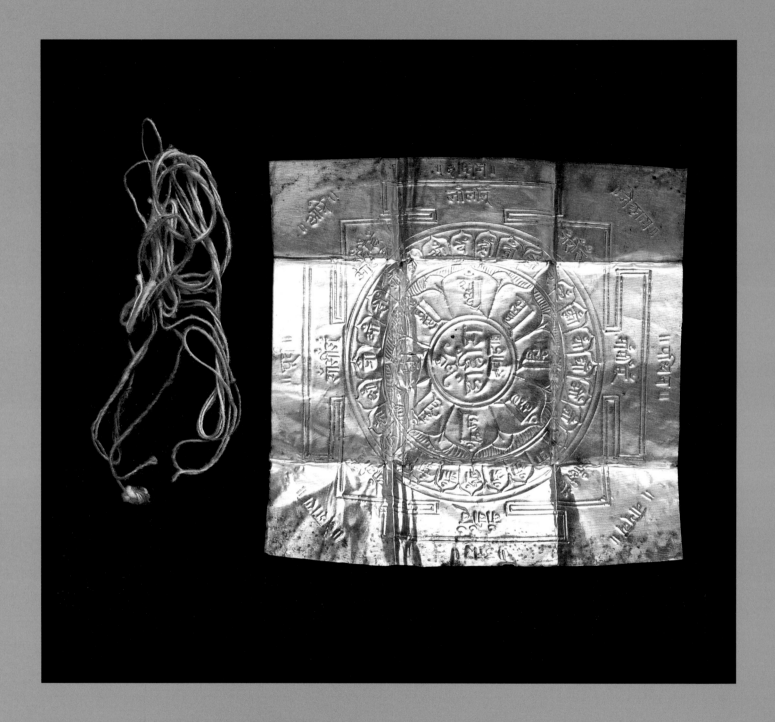

The silver amulet, found inside the amulet box to the right, consists of a petalled *yantra* with ornamental *rañjana* characters inside the eight petals, the mantra *oṃ hrāṃ hrīṃ sa svāhā* in the center and seed syllables in the smaller outer lotus petals. East (*purva*) is shown as up. The script is a transitional *devanāgarī* with some Newari characters.

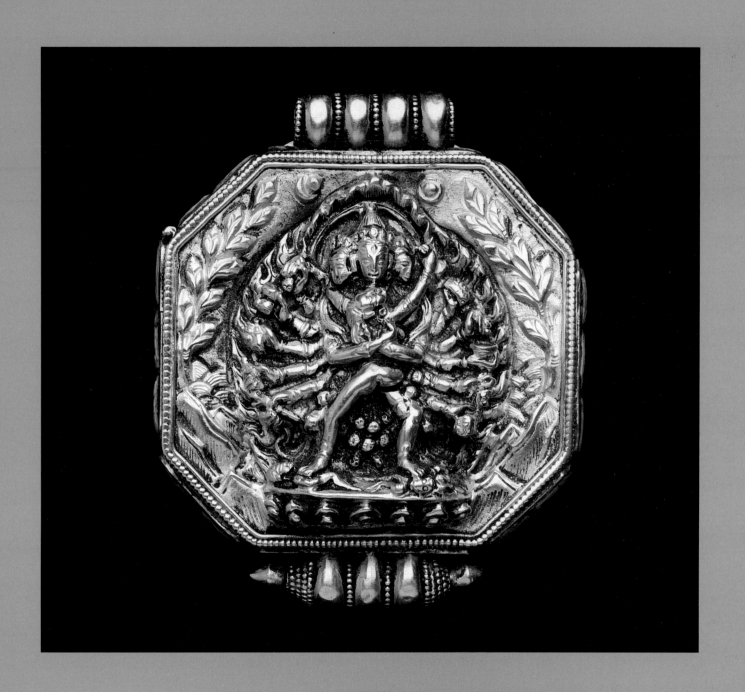

10. Amulet box adorned with Cakrasamvara and Vajravārāhī
Gold repoussé, turquoise
H: 7.1 cm; W: 5.5 cm; D: 1.5 cm

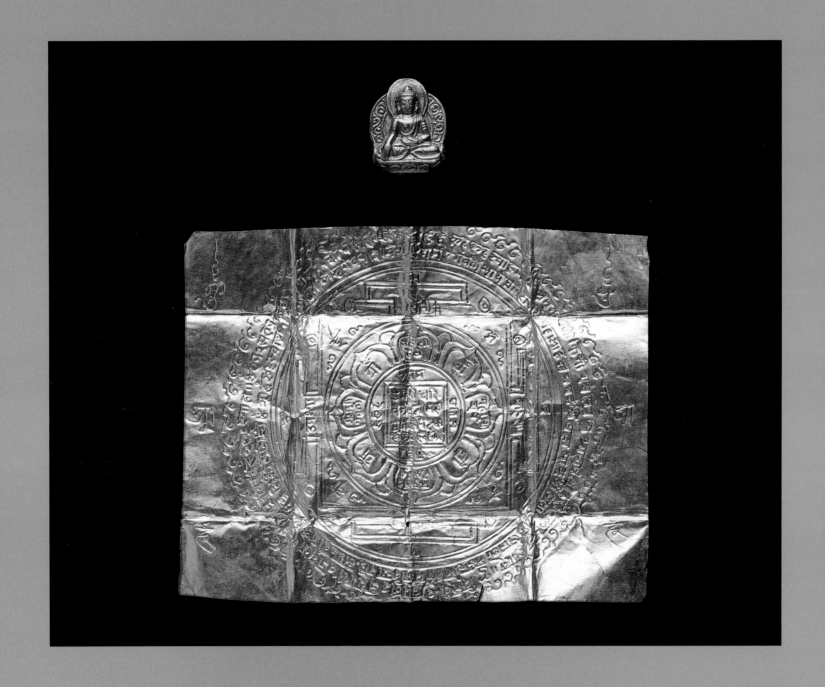

Inside this amulet box were found a gold Buddha and a gold amulet in the shape of an eight-petalled lotus. There are many mantras around the outside rim, including those of the *pañcarakṣā* ("five protector") goddesses. The script is mostly Newari with some *devanāgarī* characters.

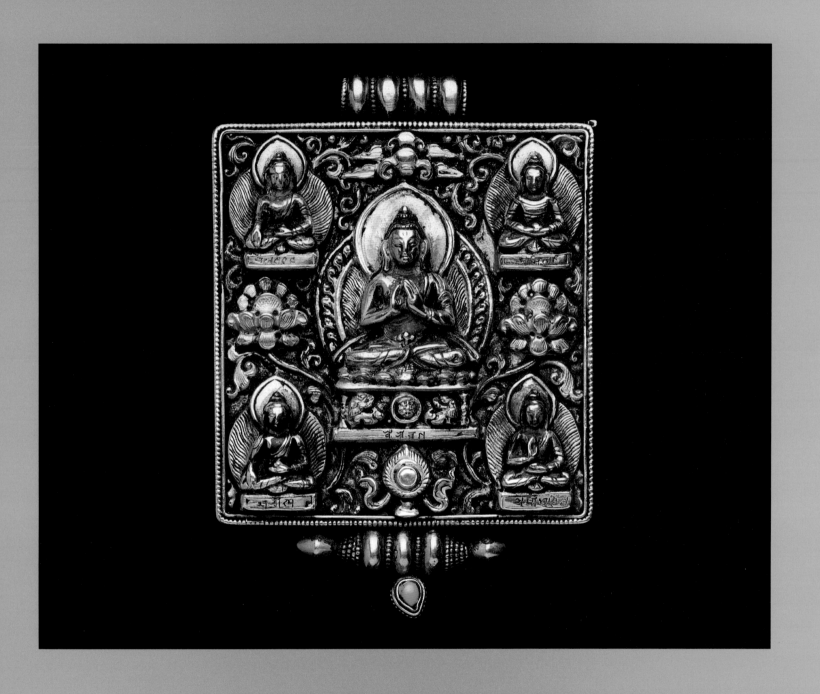

11. Amulet box adorned with Five Buddhas
Gold repoussé, turquoise
H: 9.5 cm; W: 6.8 cm; D: 1.5 cm
Each Buddha is identified by Sanskrit inscription,
clockwise from the upper left corner: Ratnasambhava,
Amitābha, Amoghasiddhi, Akṣobhya, and Vairocana in the center.

73

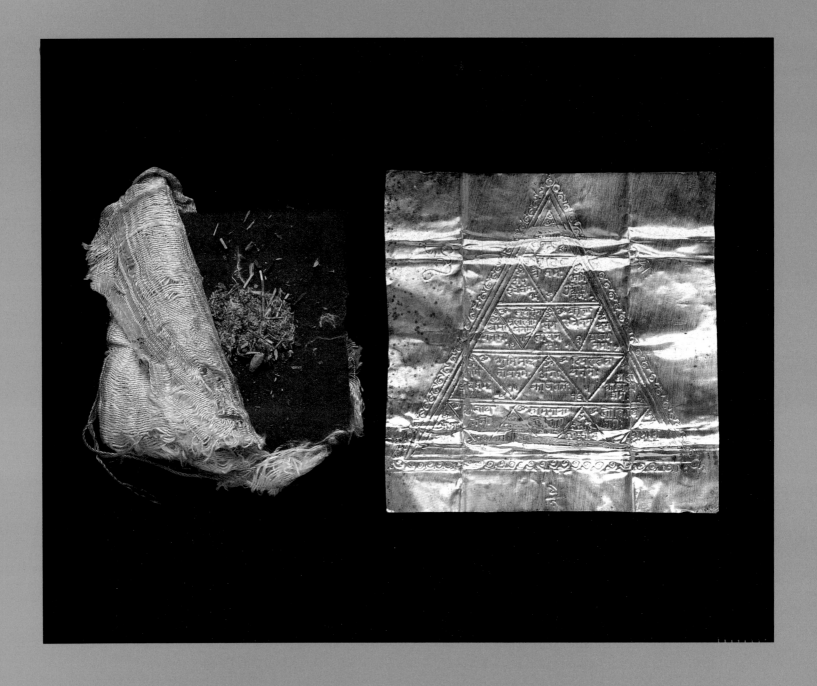

This silver amulet, found inside the amulet box on the right, is in the shape of a triangle composed of other triangles. The smaller triangles are numbered, each containing an invocation for good fortune, prosperity, and protection from fear and disease. The script is *devanāgarī* with some Newari characters.

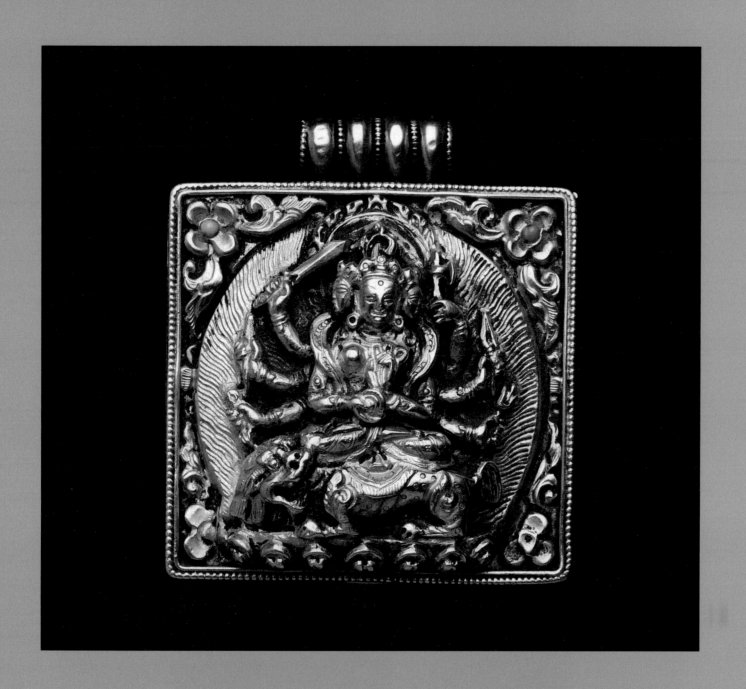

12. Amulet box adorned with Mahāpratisarā
Gold repoussé, turquoise
H: 6 cm; W: 5.2; D: 2 cm

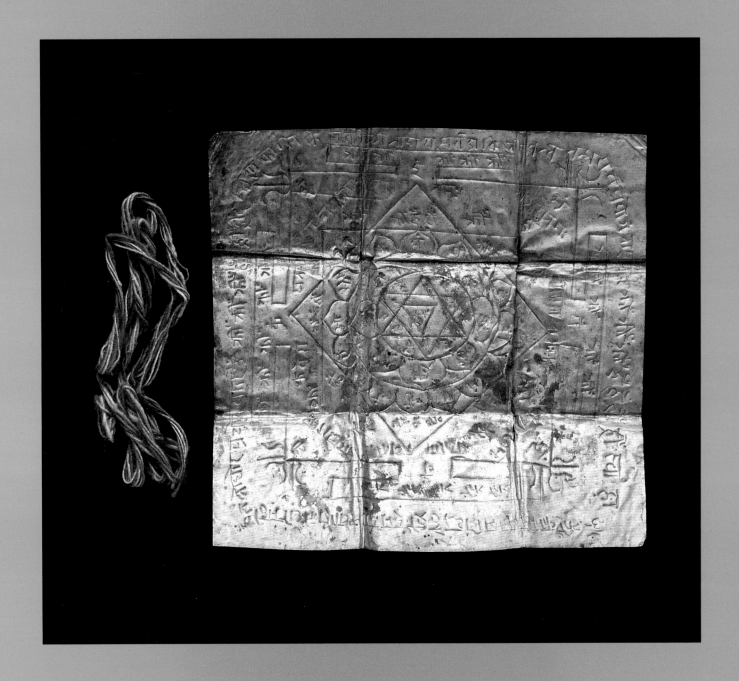

This crudely inscribed silver amulet, found inside the box on the right, combines *devanāgarī* script with some Newari characters. Mantras are inscribed along the outer rim, with shorter mantras and seed syllables inside the star pattern of the *yantra*. The goddess Vajravārāhī is associated with a hexagram, known as *dharmodayā*, "the origin of things". The mantras on the exterior seem to invoke Kālī, reading in part *oṃ … kālikā paci …* and *dakṣina kālikā*.

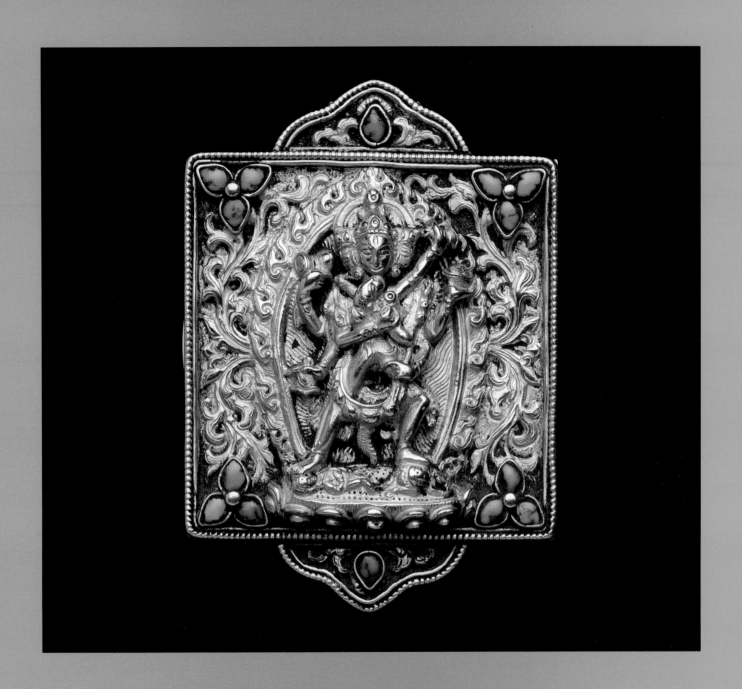

13. Amulet box adorned with Samvara and Vajravārāhī
Gold repoussé, turquoise
H: 7.3 cm; W: 5 cm; D: 1.2 cm
An inscription in Tibetan script on the side of the box reads: *oṁ maṇi padme hūṃ*.

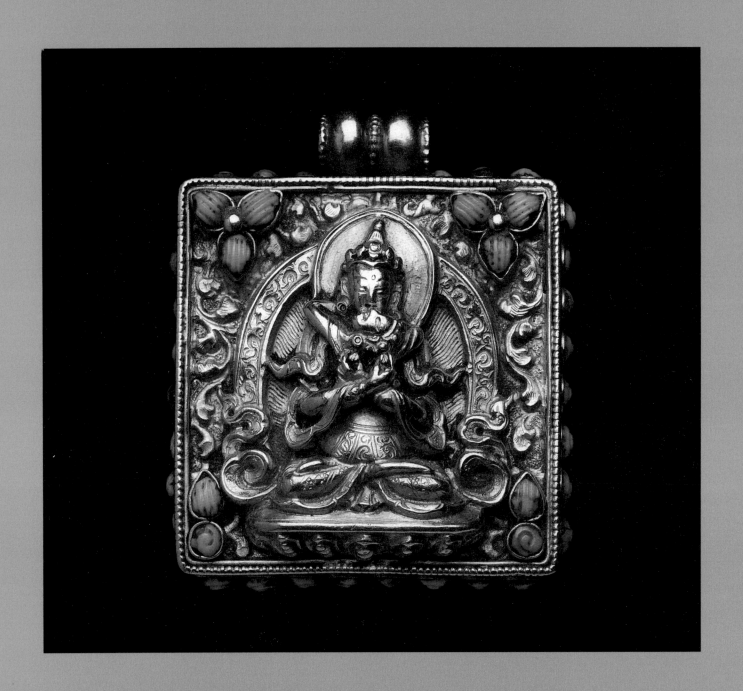

14. Amulet box adorned with Vajrasattva and Consort
Gold repoussé, turquoise
H: 6.2 cm; W: 5.3 cm; D: 1.6 cm

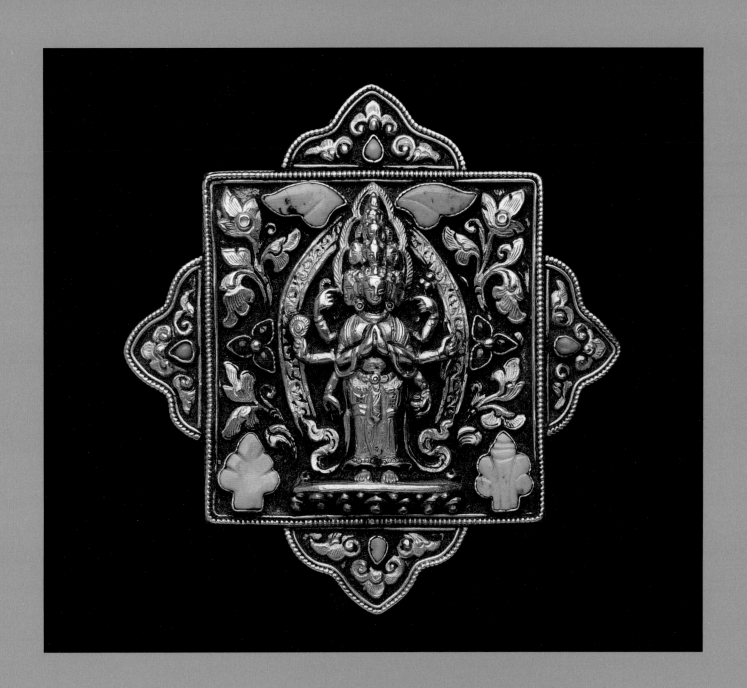

15. Amulet box adorned with Mahāsahasrasūrya Lokeśvara
Gold repoussé, turquoise, ruby
H: 9 cm; W: 8.5 cm; D: 1.4 cm

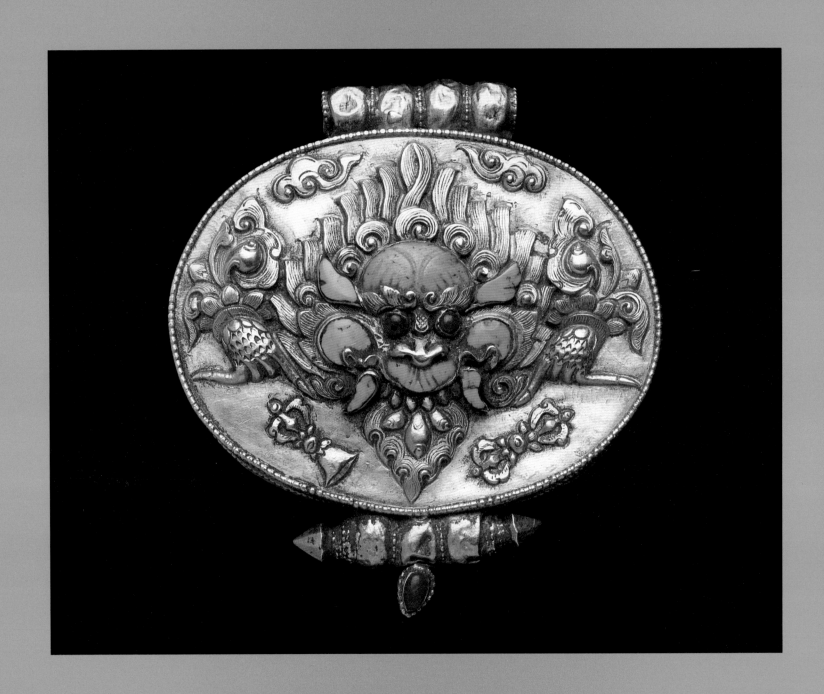

16. Amulet box adorned with Monster Mask
Gold repoussé, turquoise, carnelian
H: 8.2 cm; W: 7.6 cm; D: 1.3 cm

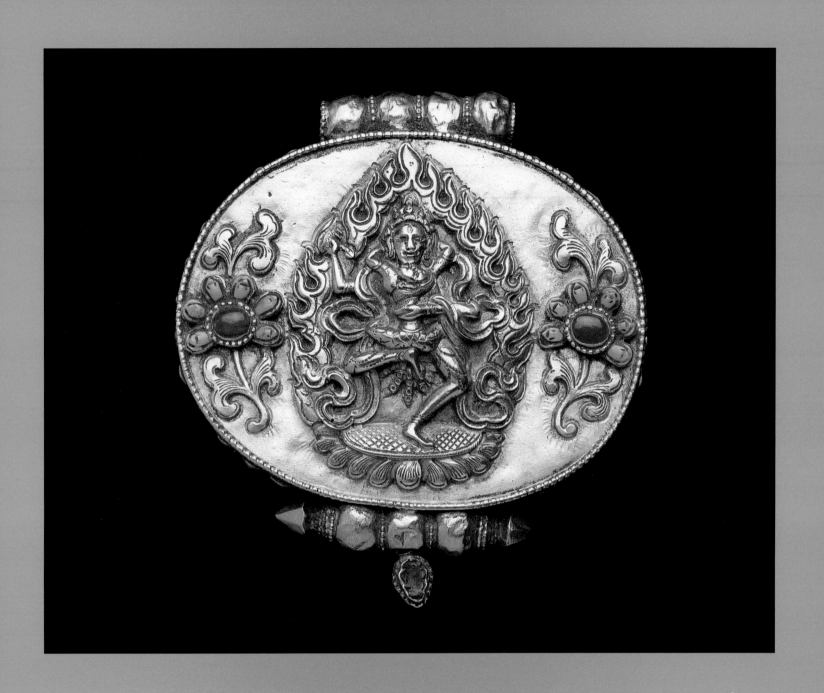

17. Amulet box adorned with Ḍāka and Ḍākinī
Gold repoussé, turquoise, carnelian
H: 7.8 cm; W: 7.3 cm; D: 1.5 cm

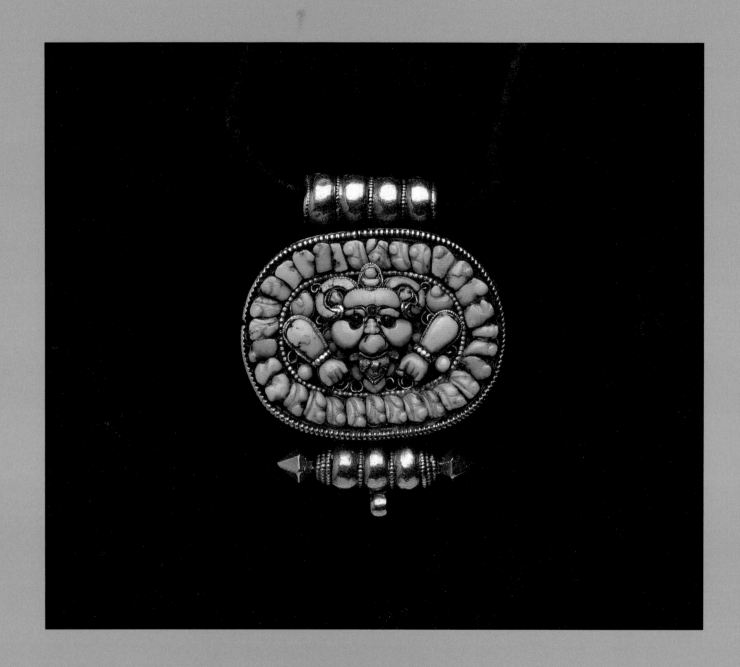

18. Amulet box adorned with Monster Mask
Gold, turquoise, glass
H: 4.9 cm; W: 3.7 cm; D: 0.7 cm

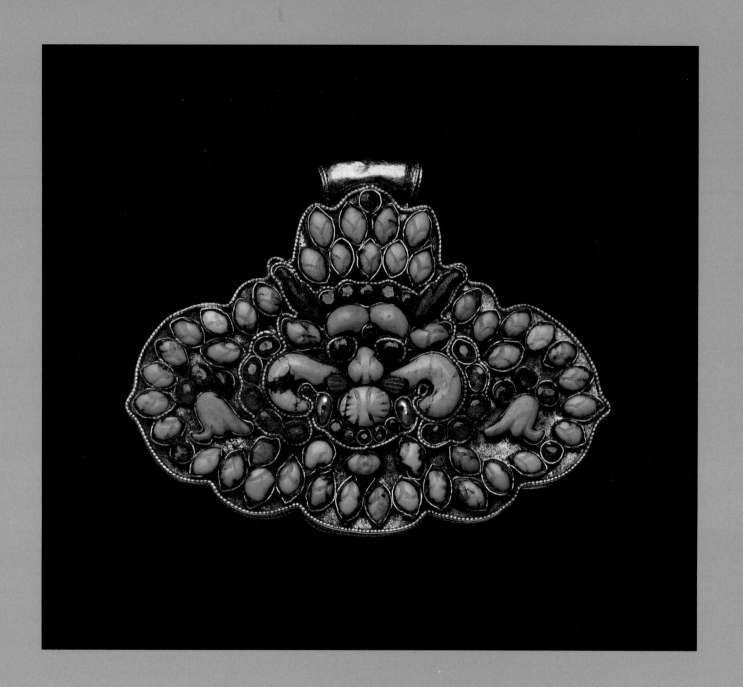

19. Amulet box adorned with Monster Mask
Gold, turquoise, pearl, lapis lazuli, coral, emerald, glass
H: 5 cm; W: 6.3 cm; D: 0.6 cm

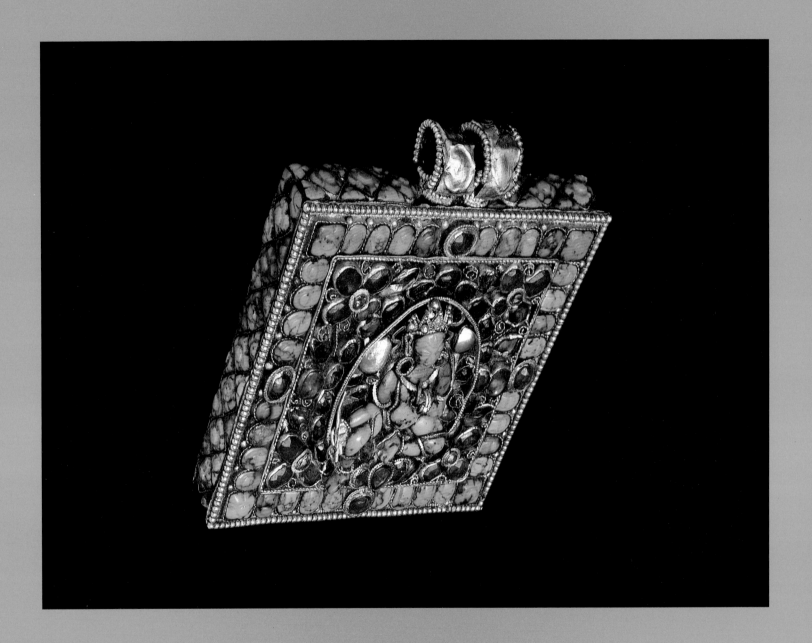

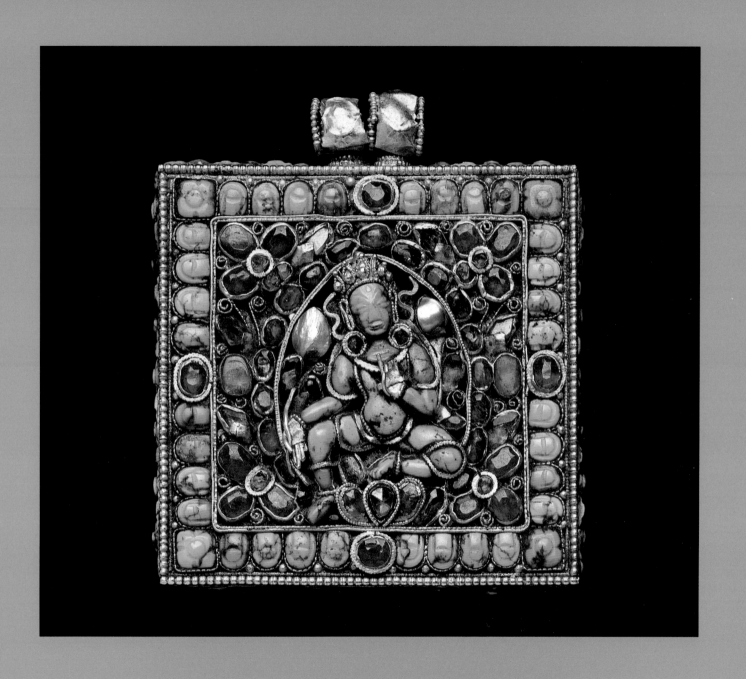

20. Amulet box adorned with Avalokiteśvara
Gold, turquoise, pearl, emerald, glass
H: 6.7 cm; W: 5.8 cm; D: 1 cm

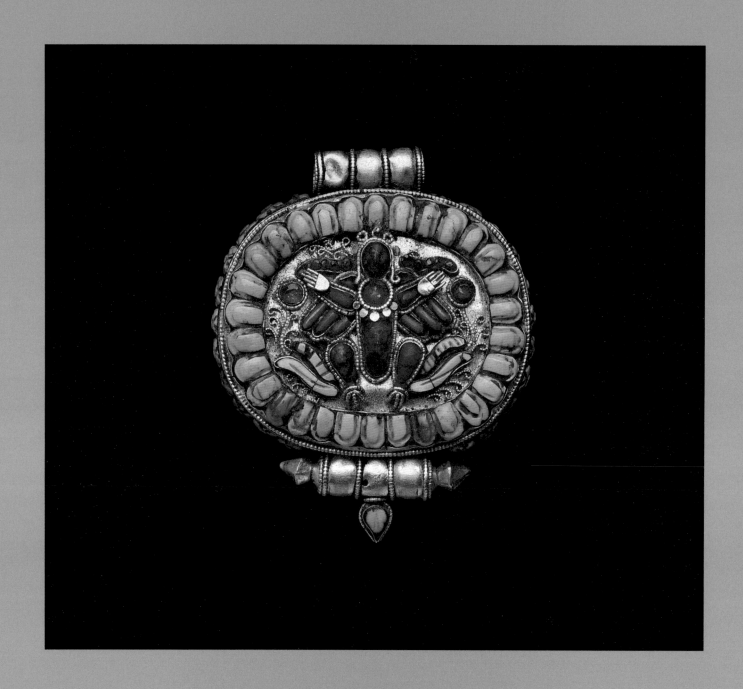

21. Amulet box adorned with Garuḍa
Gold, turquoise, lapis lazuli, coral, glass
H: 5.4 cm; W: 4.5 cm; D: 1.3 cm

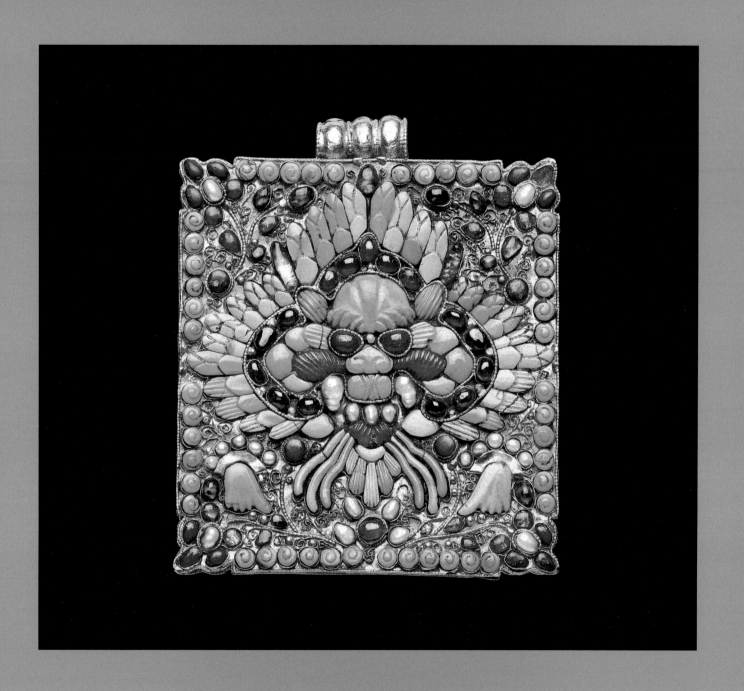

22. Amulet box adorned with Monster Mask
Gold, turquoise, pearl, ruby, coral, lapis lazuli, amethyst, emerald, glass
H: 7 cm; W: 6 cm; D: 1 cm

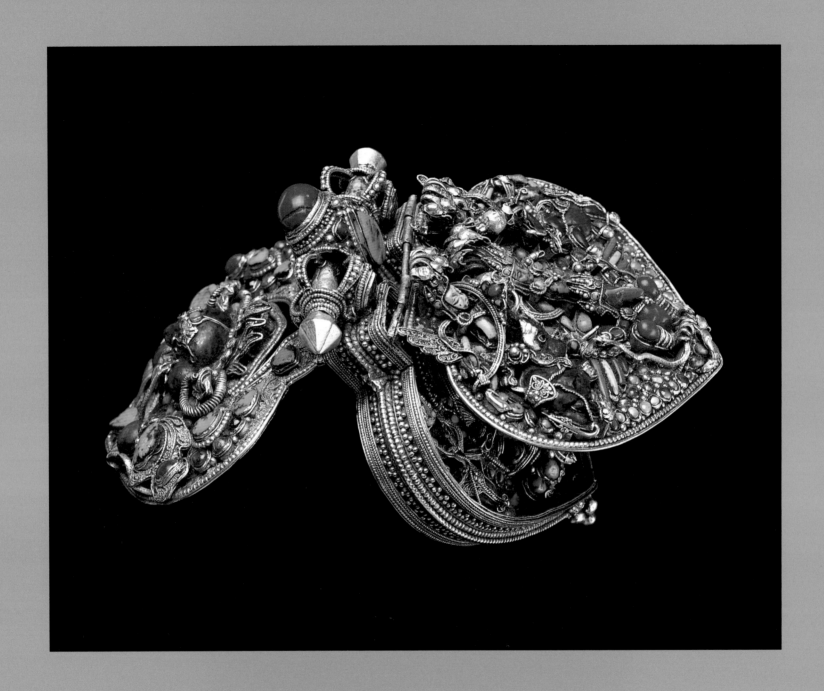

23. Pendant
Gold, turquoise, lapis lazuli, coral, emerald, garnet, other semiprecious gems, glass
H: 10.6; W: 8.5 cm; D: 4.8 cm

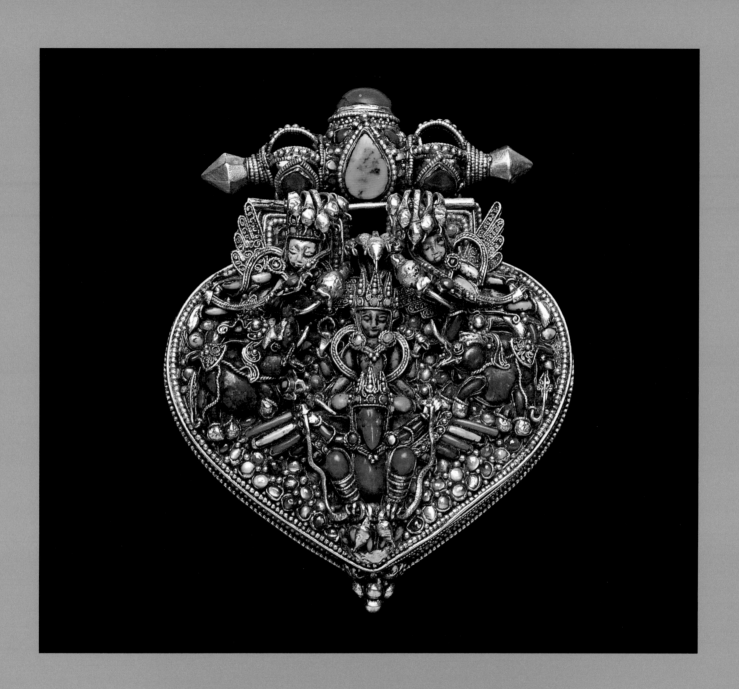

Viṣṇugaruḍāsana
The Hindu god Viṣṇu is seated on his winged mount, Garuḍa, attended by pairs of elephants and *apsarās*.

89

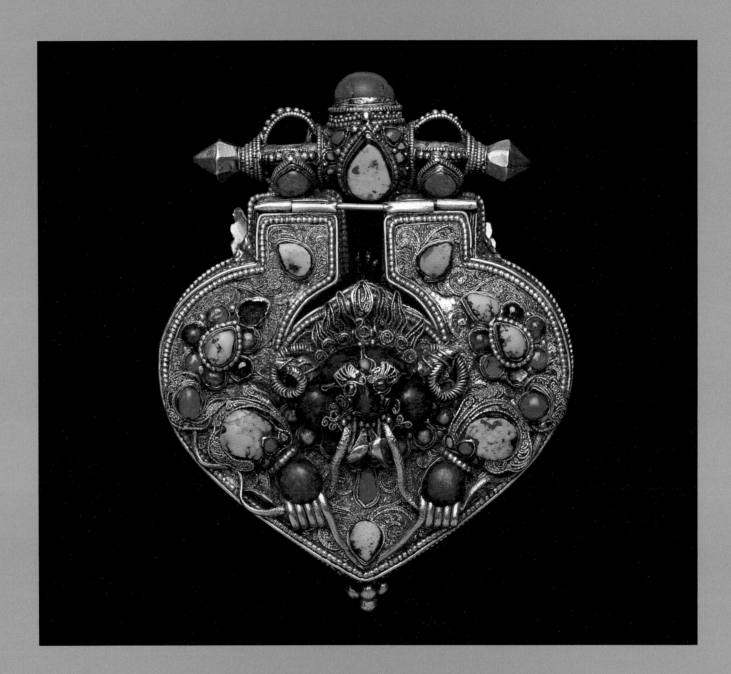

Monster Mask

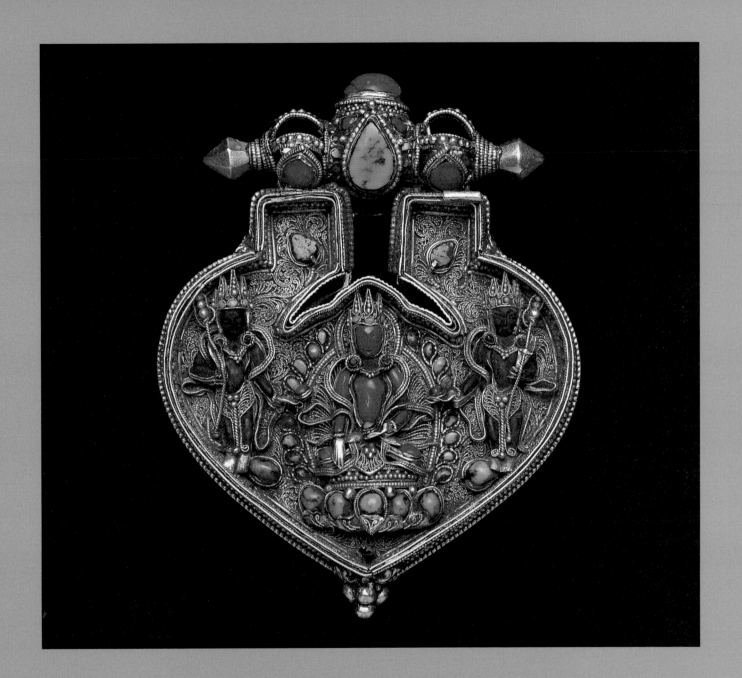

The Buddha Akṣobhya and attendants

91

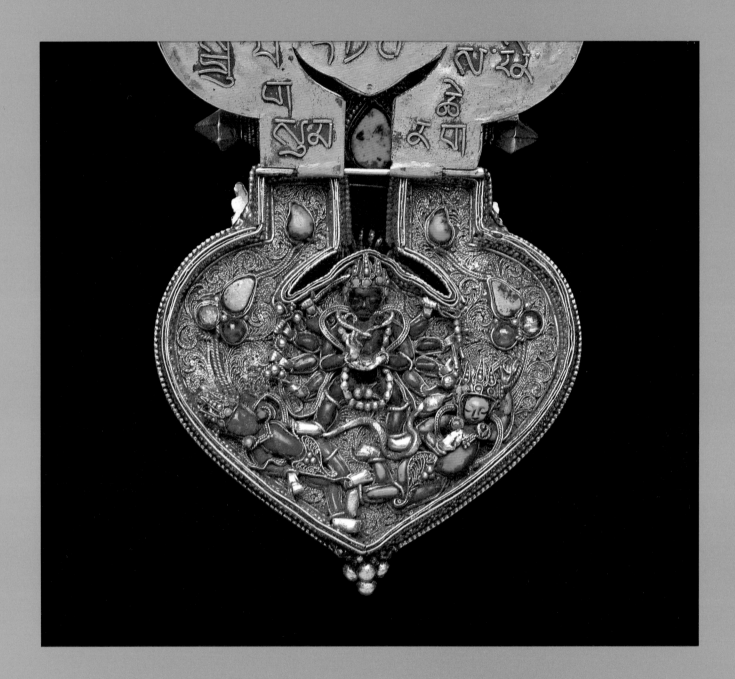

Esoteric deity

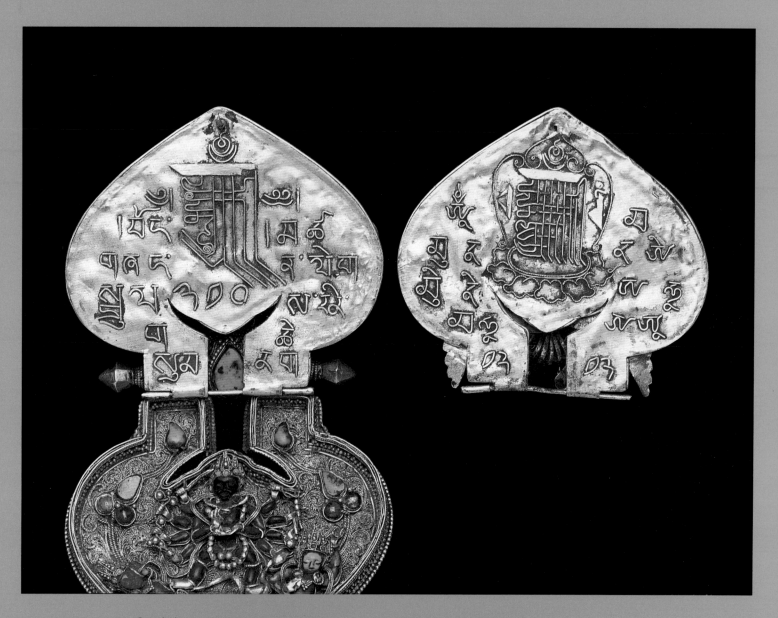

Inscriptions
On the left: In the center, a large monogram character in the ornamental Sanskrit *rañjana* script.
Surrounding it, in corrupt Tibetan: "Tibetan government [year] 210, third snake [month]; Senlek,
Rinchen [the names of two Medicine Buddhas]." The 210 probably refers to an obscure Tibetan
calendrical system established in 1642 by the Tibetan government in Lhasa, making for a date of 1852 AD.
On this calendrical system, see Dieter Schuh, *Untersuchungen zur Geschichte der Tibetischen
Kalenderrechnung* (Wiesbaden: Franz Steiner Verlag, 1973).

On the right: In the center, a large monogram character in the ornamental Sanskrit *rañjana* script.
Surrounding it in Tibetan script is a corrupt rendering of Śākyamuni's mantra, *om muni mahāmuni ye svāhā*.
The number twelve appears twice.

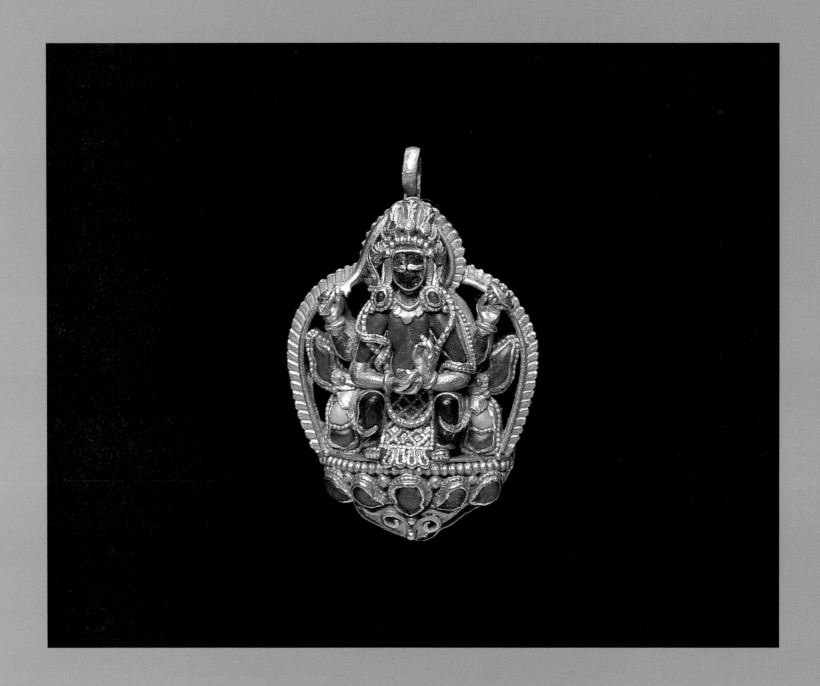

24. Pendant featuring four-armed Viṣṇu
Gold, lapis lazuli, semiprecious gems
H: 3 cm; W: 2 cm

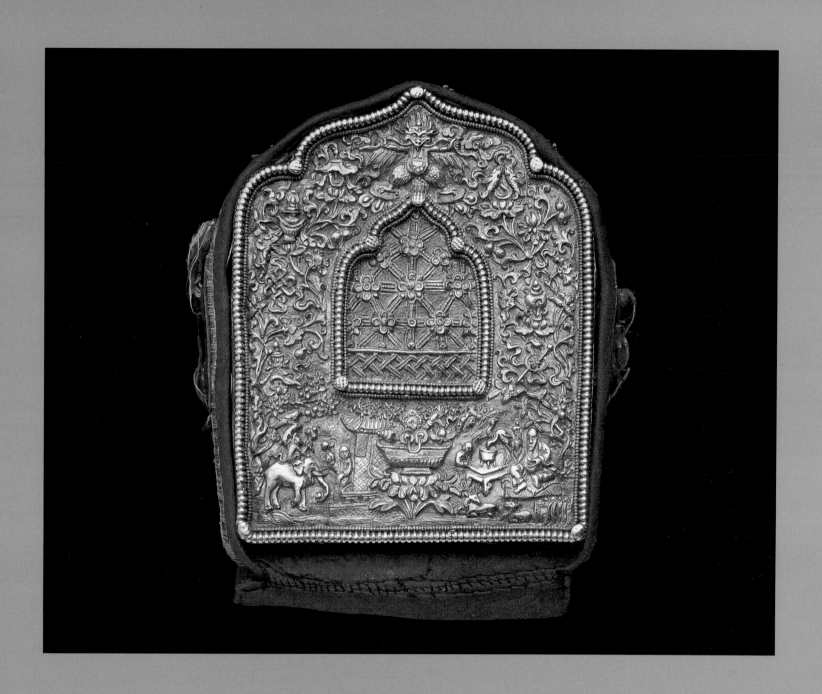

25. Portable shrine (t. *g'au*)
Gold repoussé front panel (back in silver)
H: 8.8 cm; W: 9 cm; D: 4.7 cm

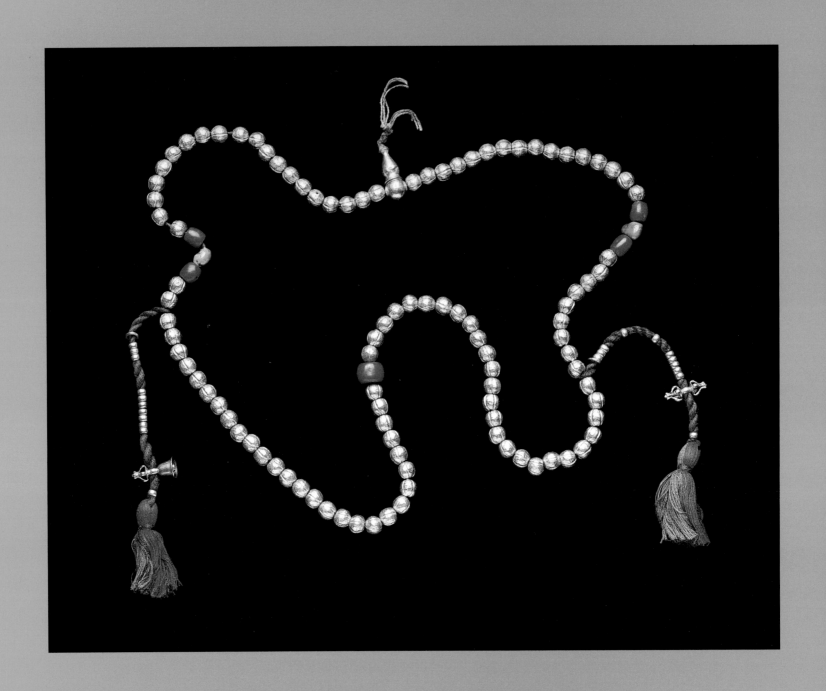

26. Prayer beads (t. *'phreng-ba*)
Gold, turquoise, coral
Length: 42 cm (excluding counters)

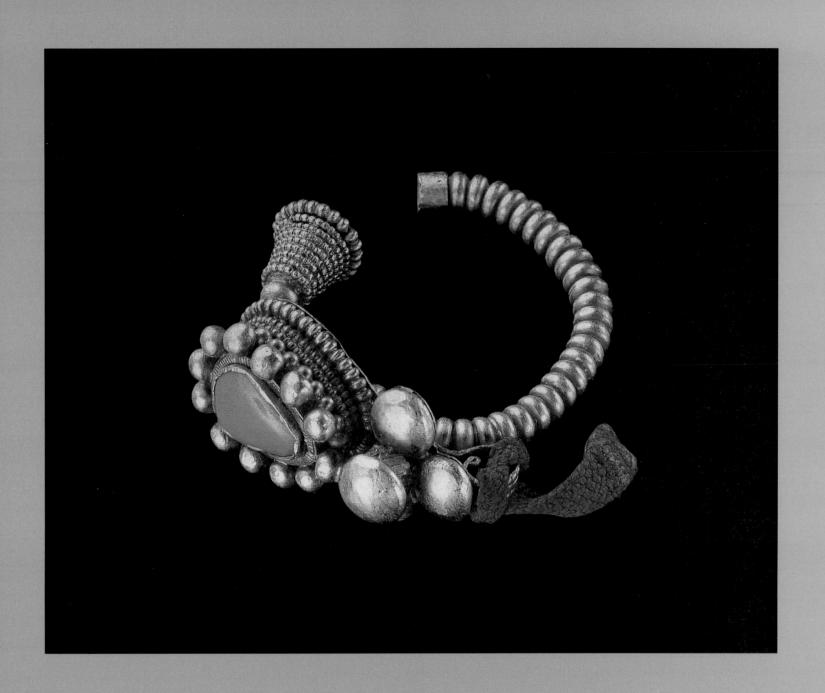

27. Man's earring
Gold, turquoise
H: 6.5 cm; W: 5.5 cm

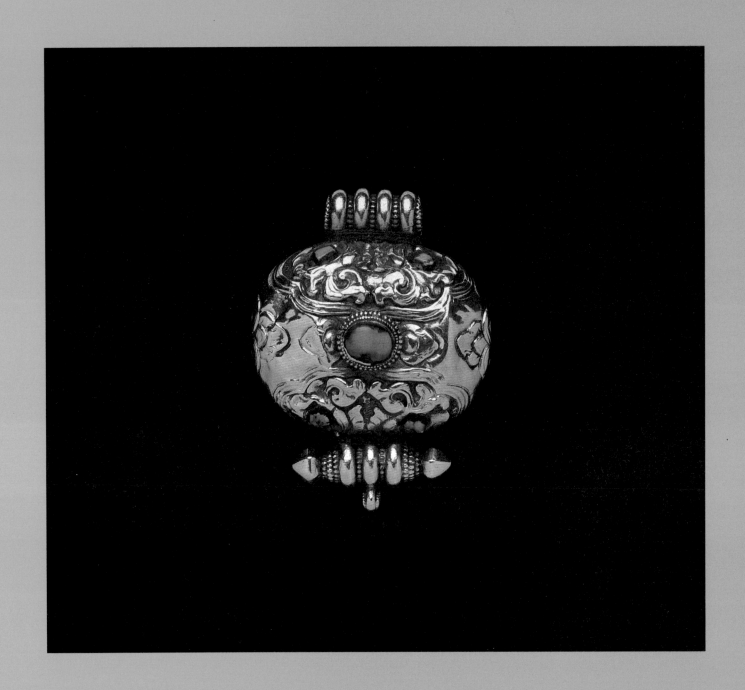

28. Man's hair ornament & amulet box
Gold repoussé, turquoise
H: 4 cm; W: 3 cm; D: 1.5 cm

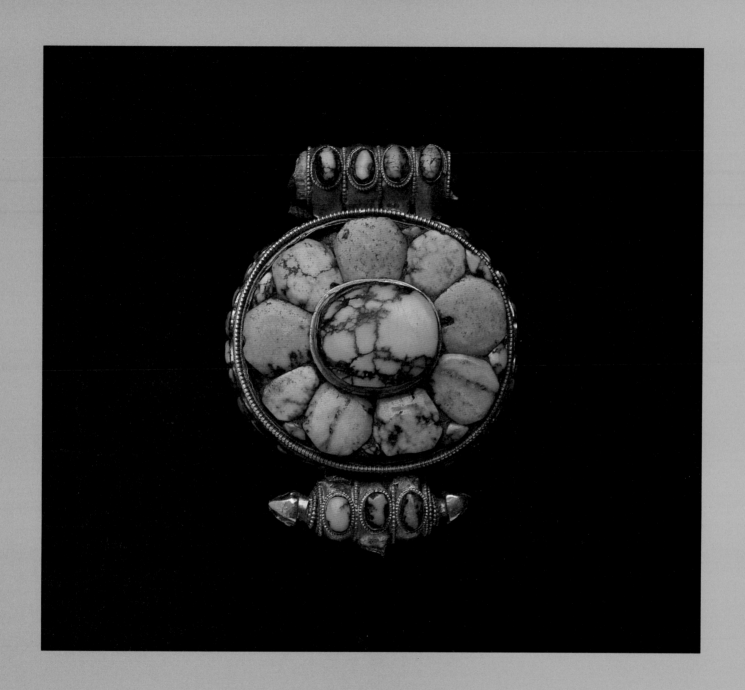

29. Man's hair ornament & amulet box
Gold, turquoise
H: 6.4 cm; W: 4.2 cm; D: 2 cm

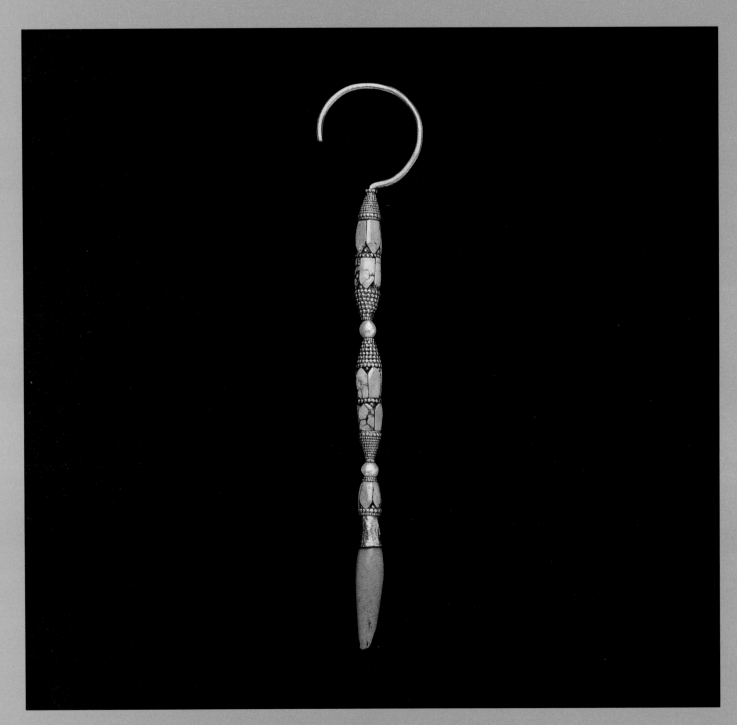

30. Government official's earring (t. *so-byis*)
Gold, turquoise, pearl, glass
Height: 17.4 cm

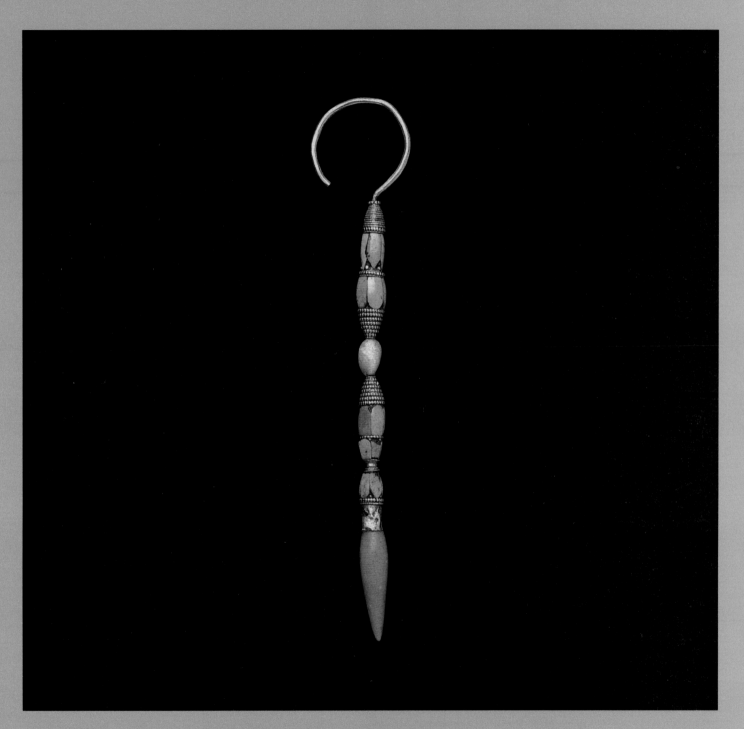

31. Government official's earring (t. *so-byis*)
Gold, turquoise, pearl, glass
Height: 18 cm

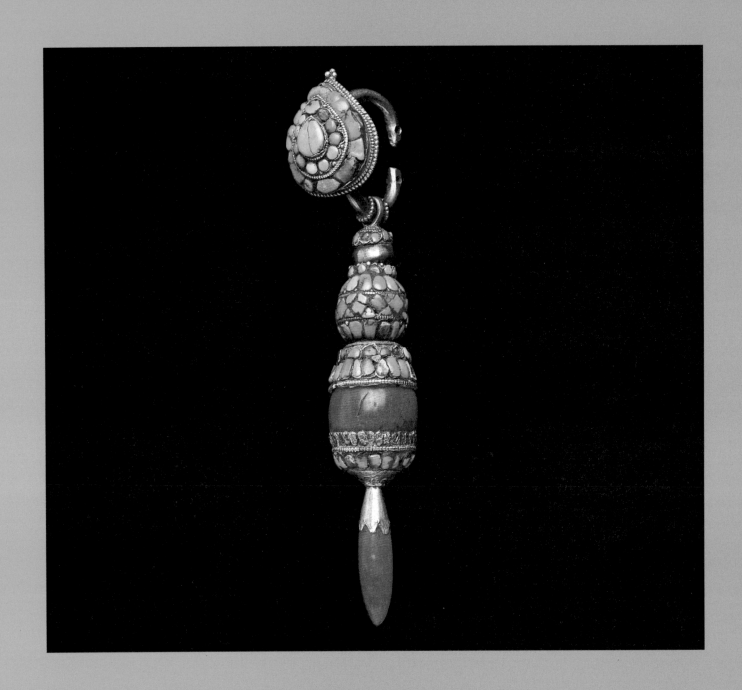

32. Earring
Silver, gold, turquoise, coral
Height: 9.4 cm

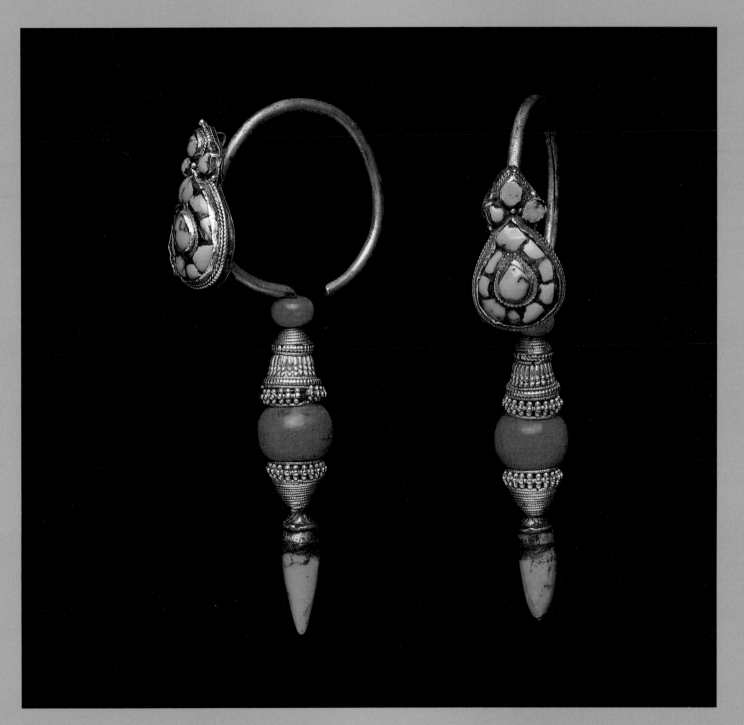

33. Pair of earrings
Gold, turquoise, coral, glass
Height: 12 cm

103

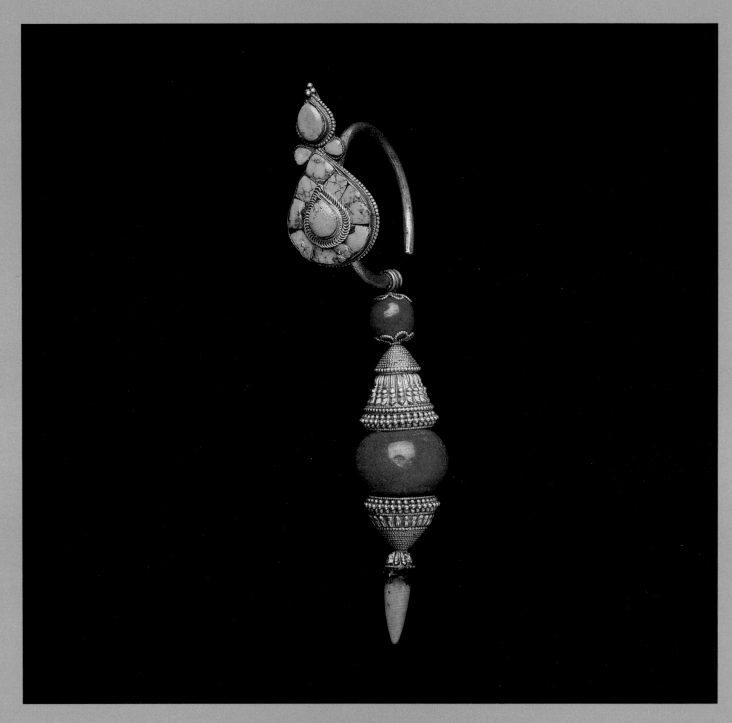

34. Earring
Gold, silver, brass, turquoise, coral, glass
Height: 16 cm

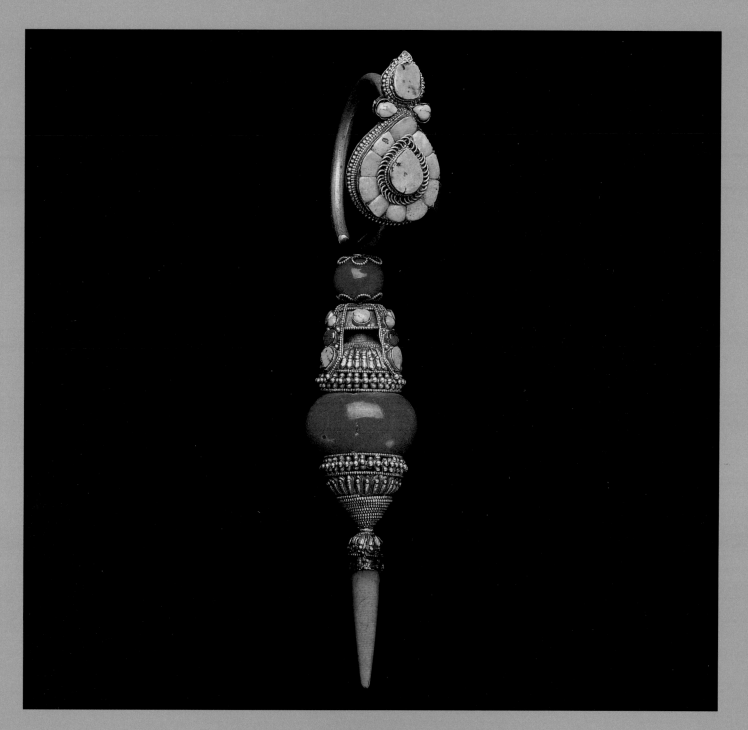

35. Earring
Gold, brass, turquoise, coral, glass
Height: 16 cm

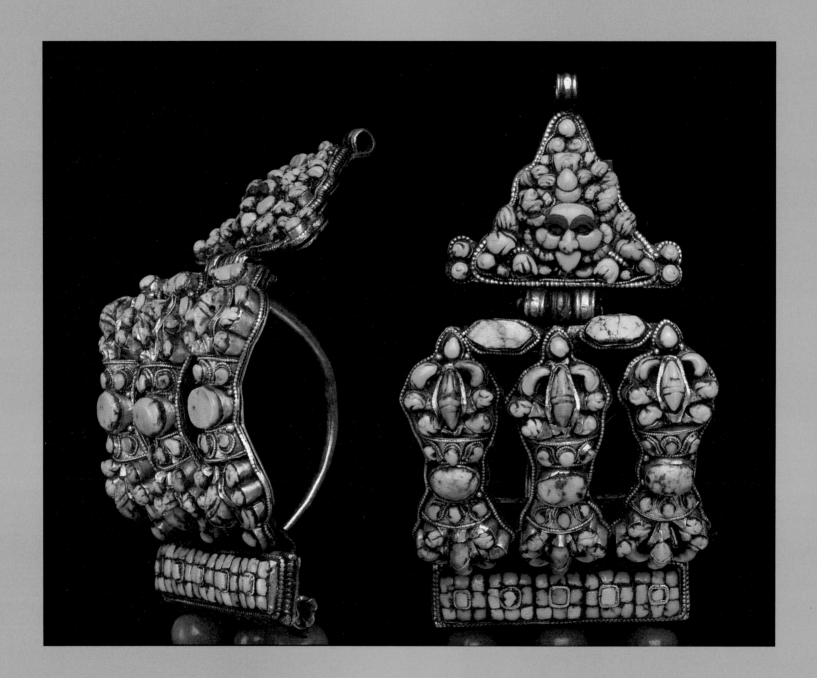

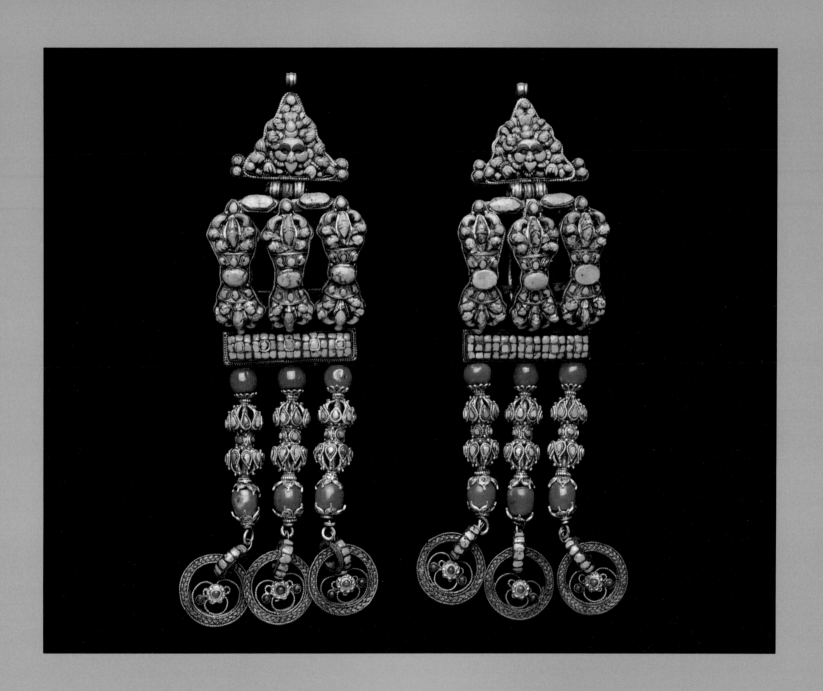

36. Official's ornaments
Gold, silver, gilt iron, turquoise, lapis lazuli, coral
H: 21.7 cm; W: 5.7 cm

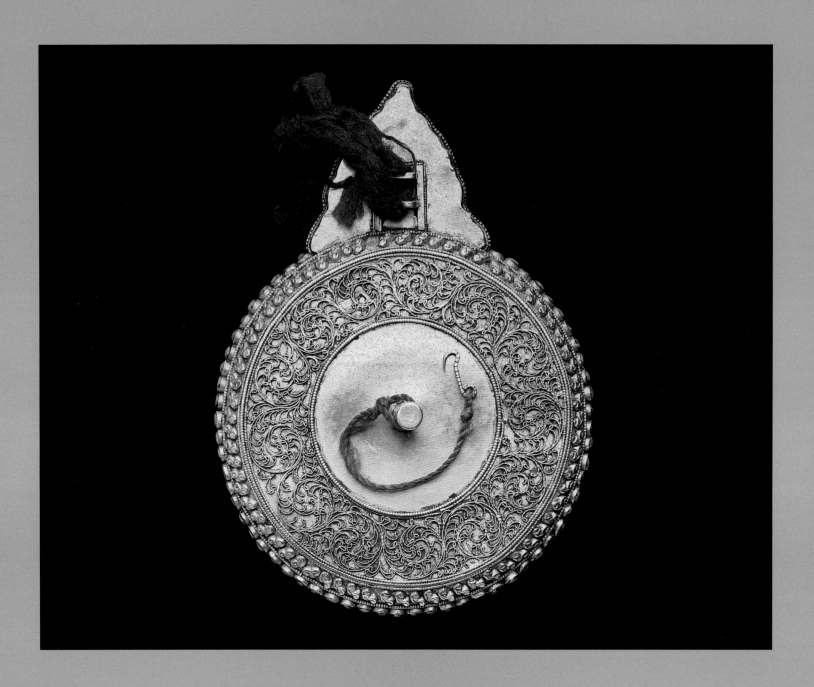

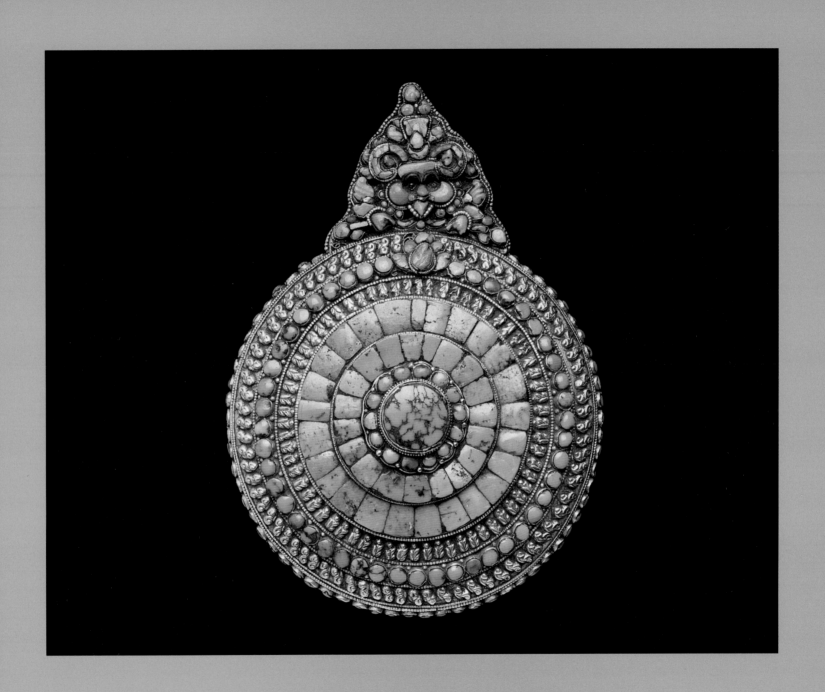

37. Government official's ornament
Gold, turquoise, lapis lazuli, ruby
H: 14.5 cm; W: 9.5 cm; D: 3.2 cm

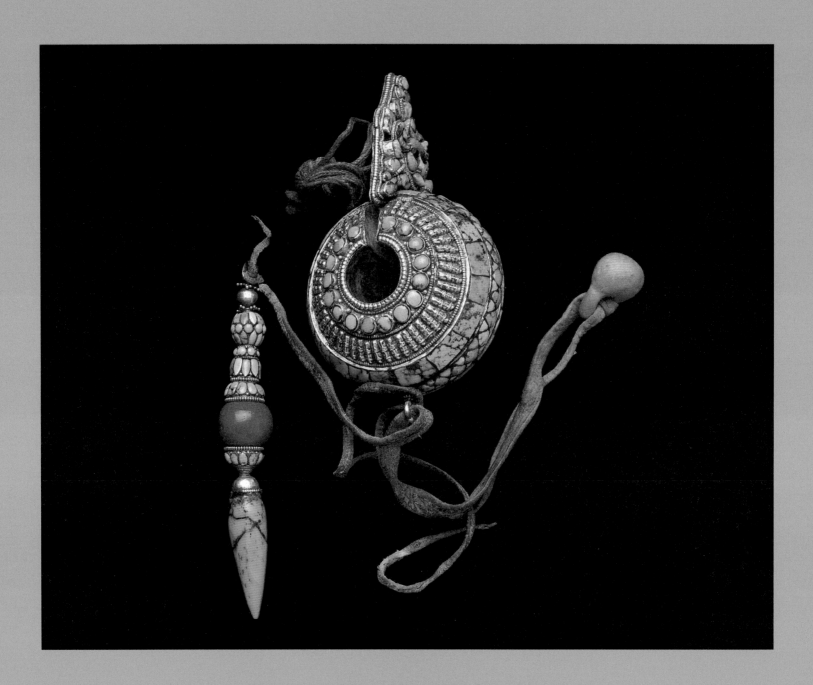

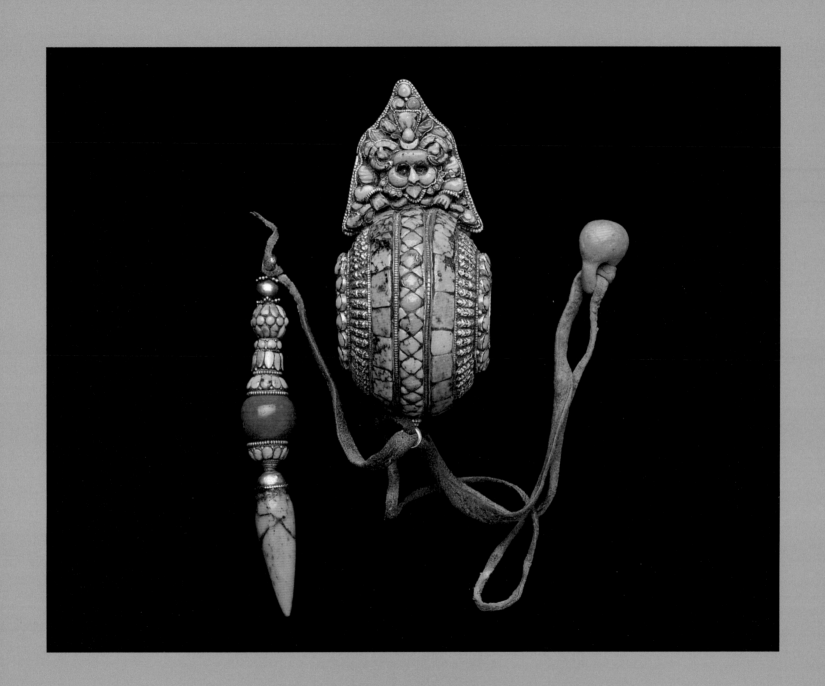

38. Government official's ornament
Gold, silver, turquoise, lapis, coral, other semiprecious gems
Main ornament H: 11 cm; W: 6.3 cm; D: 4.2 cm
Pendant height: 9.6 cm

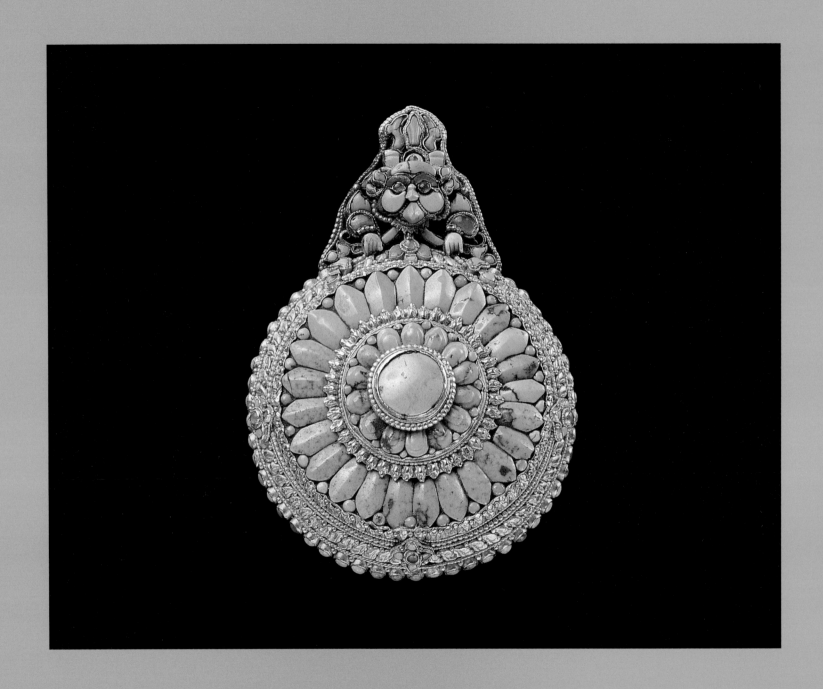

39. Government official's ornament
Gold, turquoise, lapis lazuli, other semiprecious gems
H: 10 cm; W: 6.5 cm

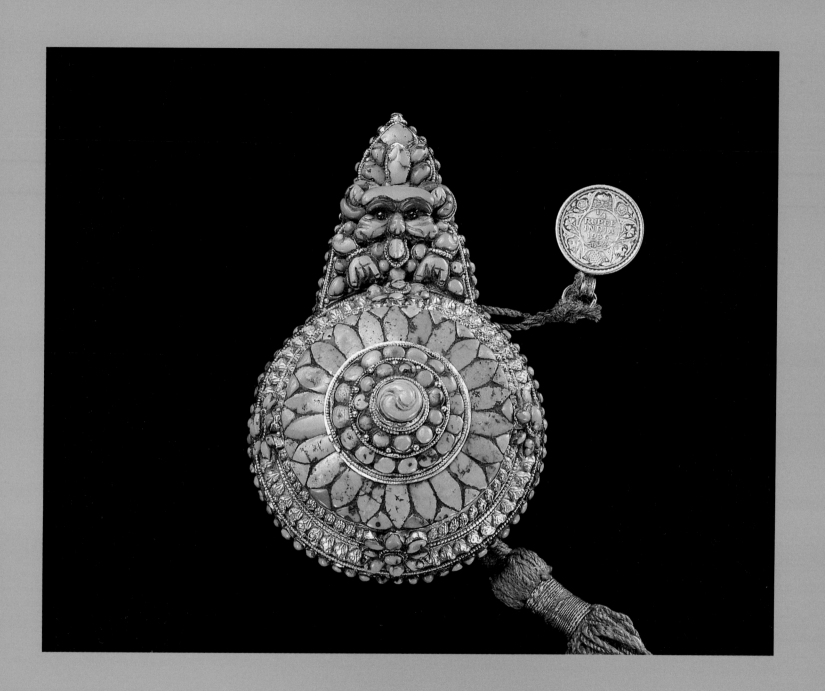

40. Government official's ornament
Gold, turquoise, lapis lazuli, other semiprecious gems
H: 7.5 cm; W: 5.5 cm

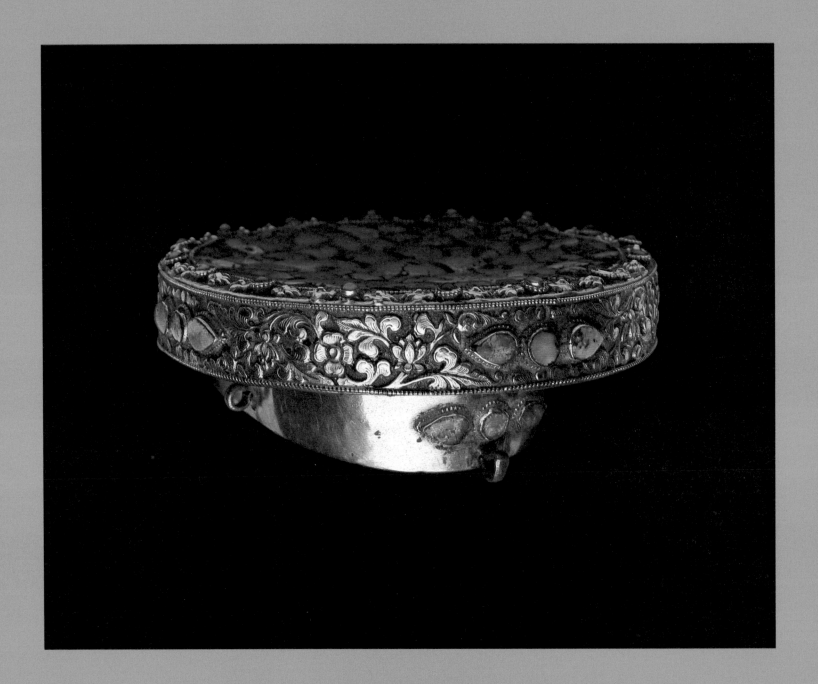

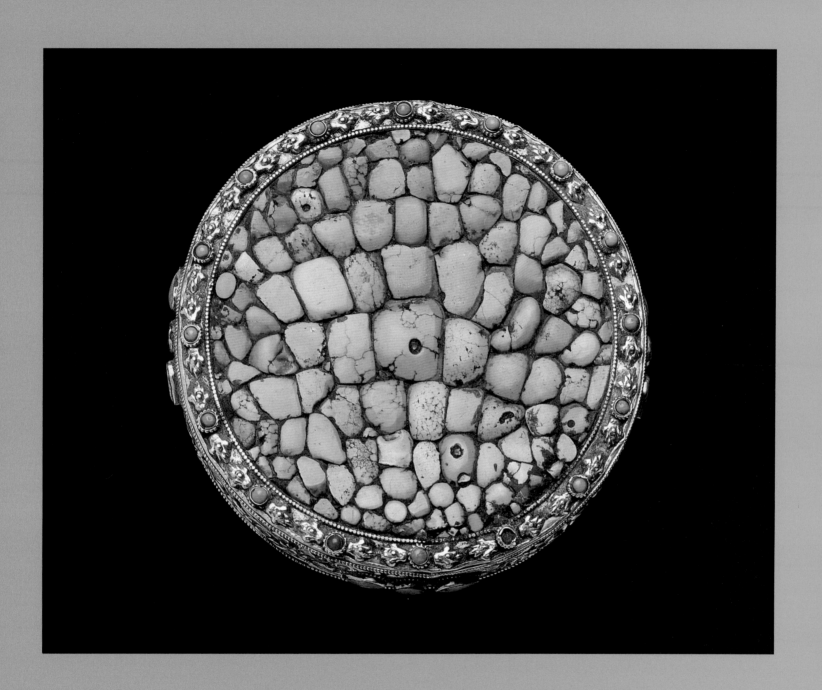

41. Government official's headpiece
Gold, turquoise
Diameter: 9.7 cm

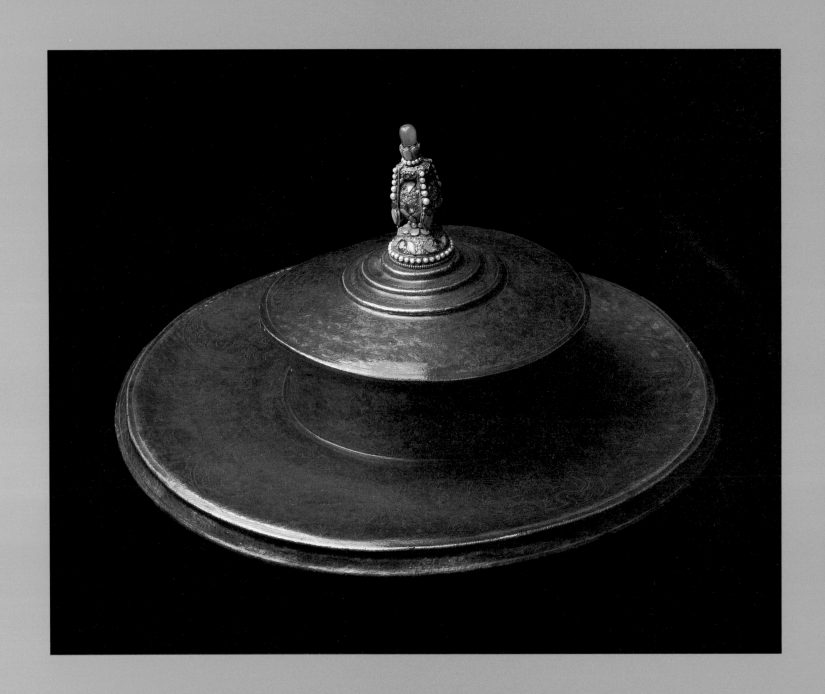

42. Government official's summer hat
Painted, lacquered leather
Diameter: 38.5 cm

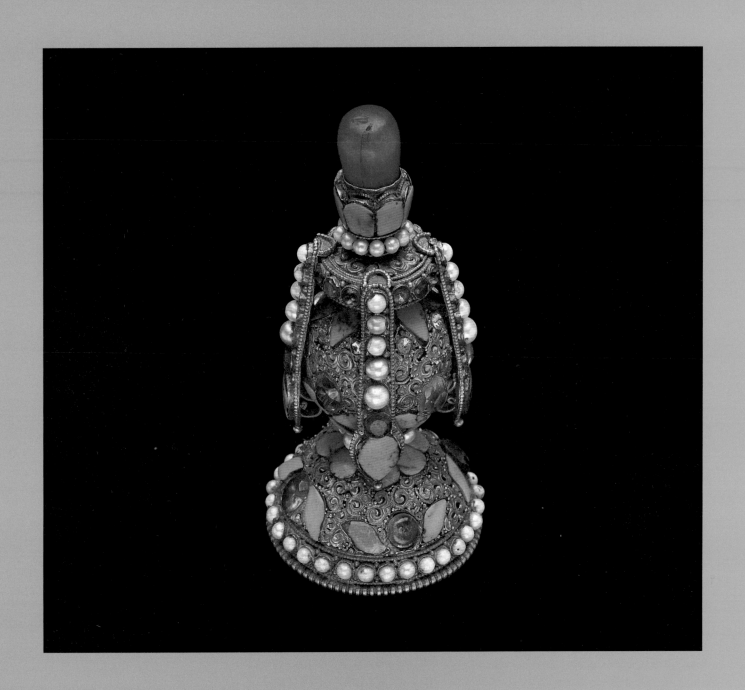

Vase-shaped ornament
Gold, turquoise, pearl, glass
H: 9 cm

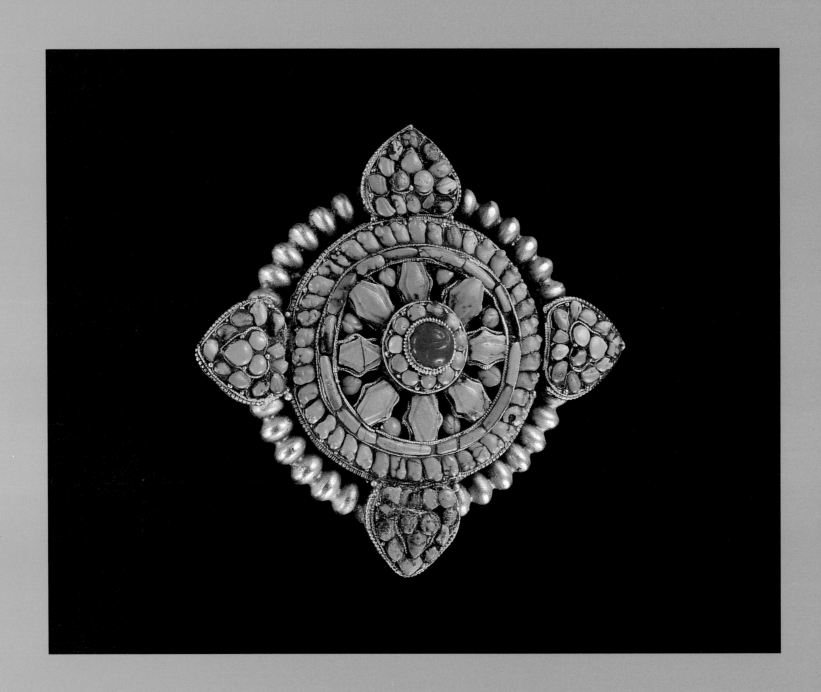

43. Ornament
Gold, turquoise, coral
H: 7 cm; W: 7 cm

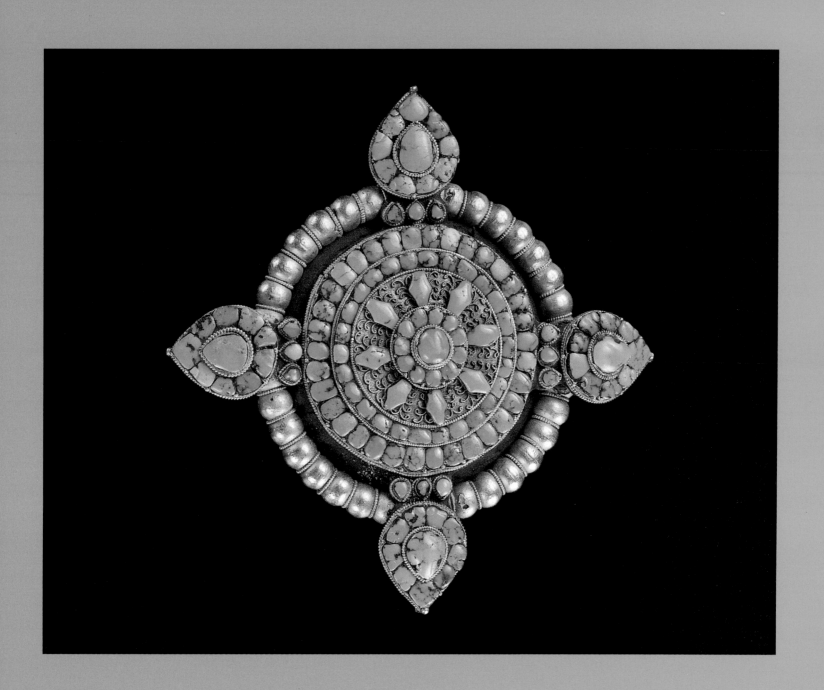

44. Ornament
Gold, turquoise, felt
H: 12 cm; W: 12 cm

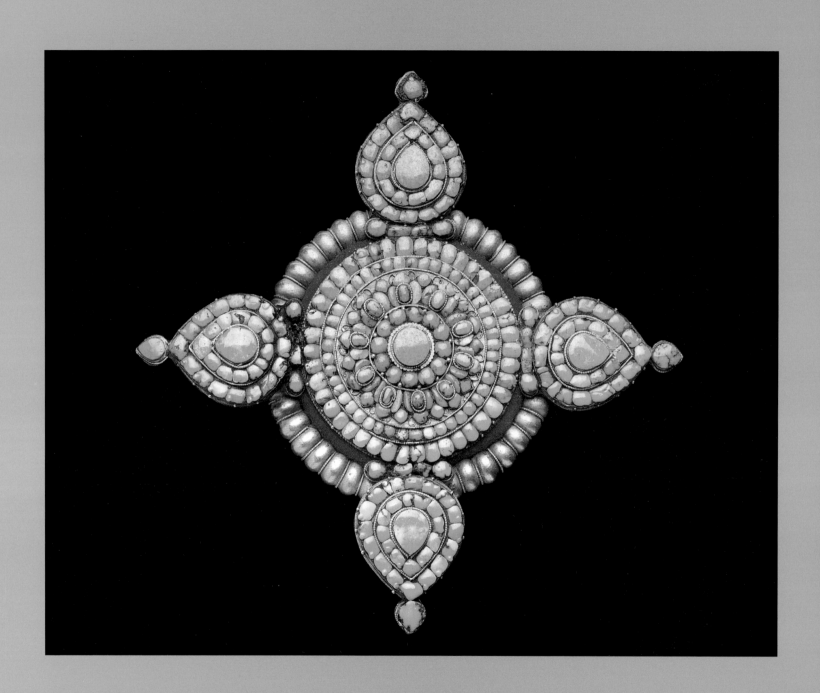

45. Ornament
Gold, turquoise, felt
H: 15.4 cm; W: 15.2 cm; D: 1.8 cm

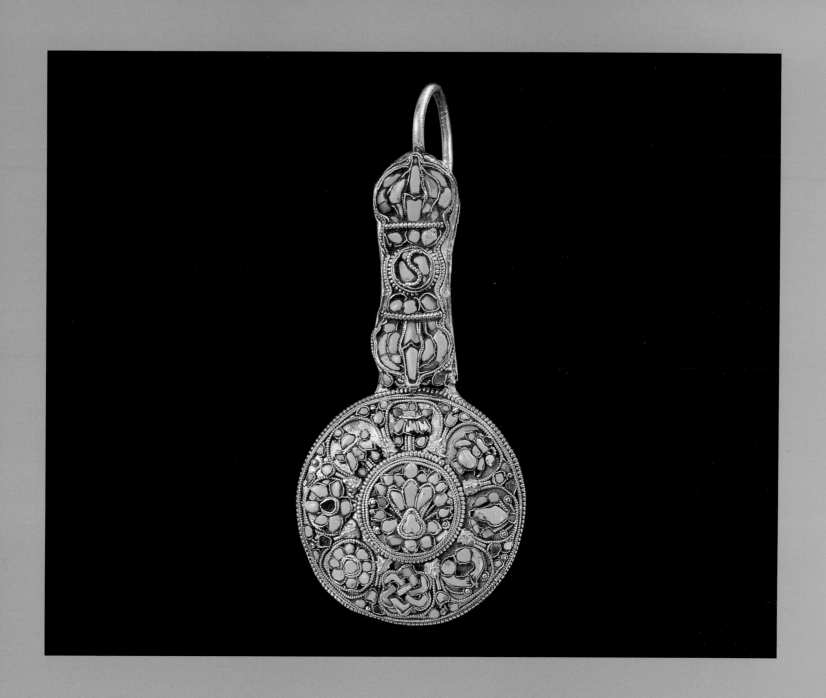

46. Government official's ornament
Gold, turquoise
H: 11 cm; W: 4.5 cm

121

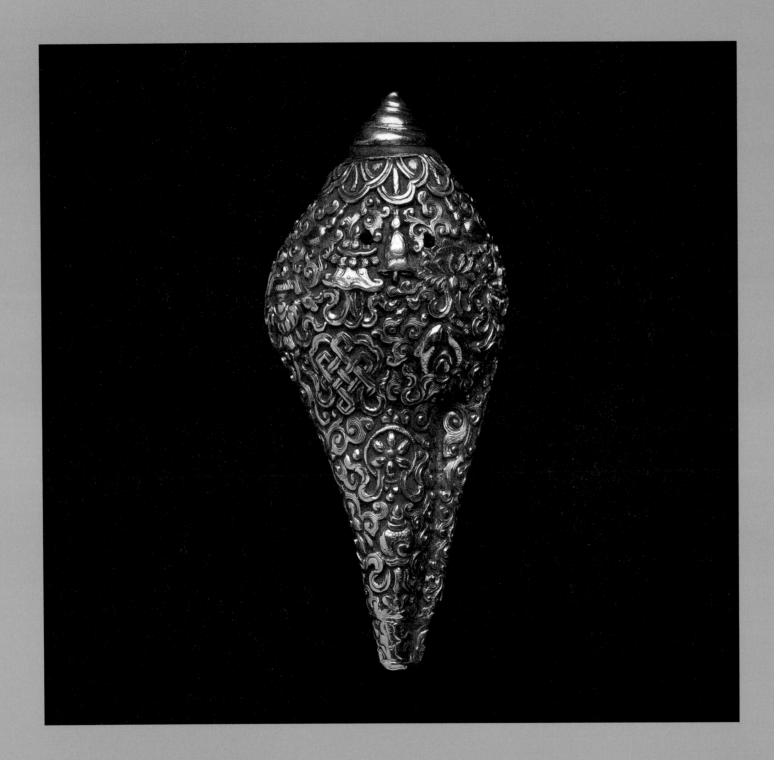

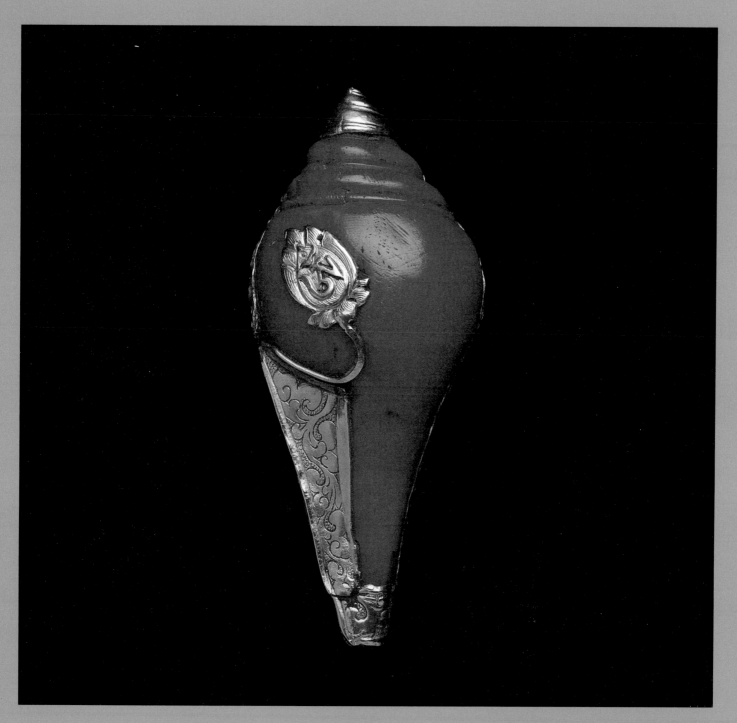

47. Ornamental conch
Gold, coral
Height: 9 cm

123

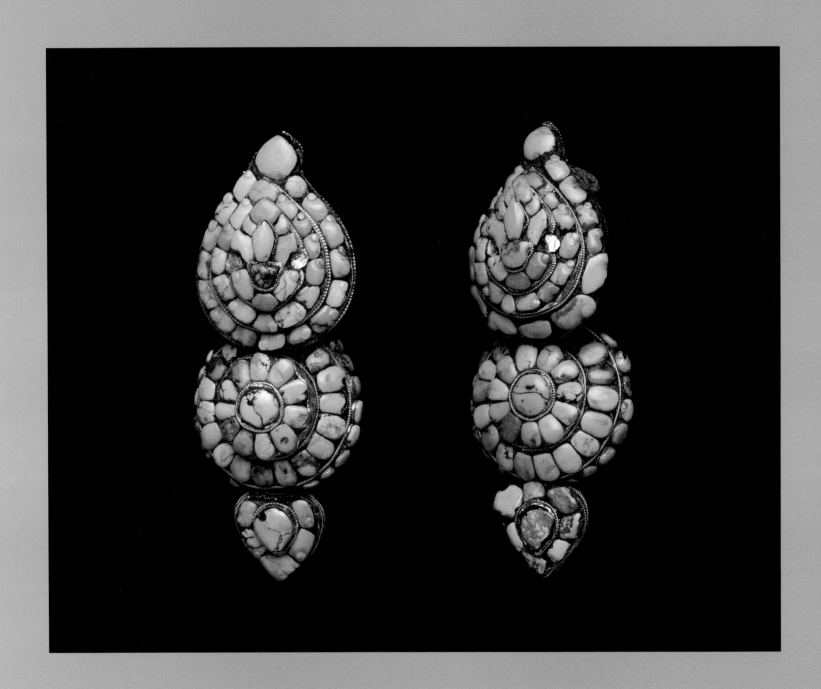

48. Woman's ear pendants
Gold, turquoise
H: 7.5 cm; W: 3 cm

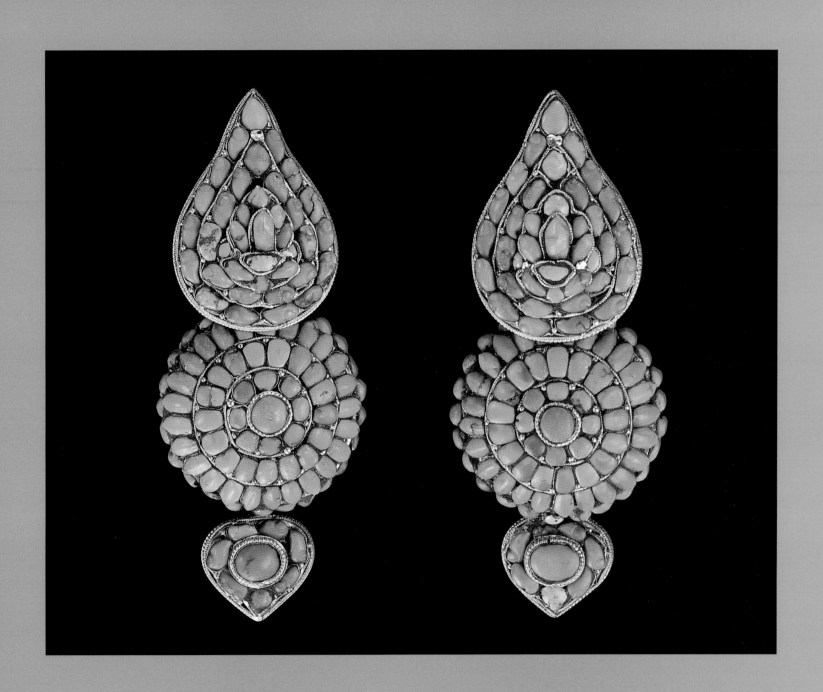

49. Woman's ear pendants
Gold, turquoise
H: 9.5 cm; W: 4 cm

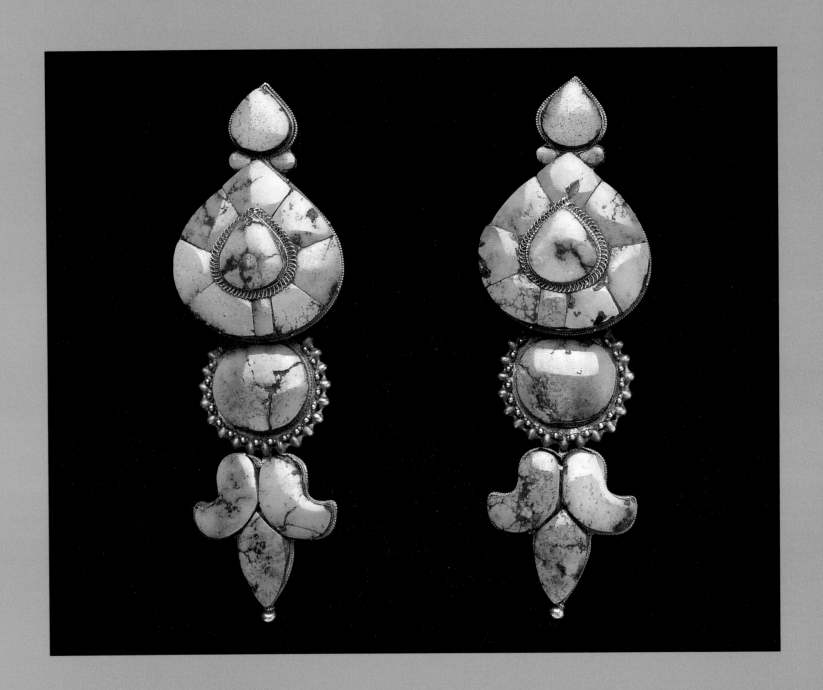

50. Woman's ear pendants
Gold, turquoise
H: 14 cm; W: 5 cm

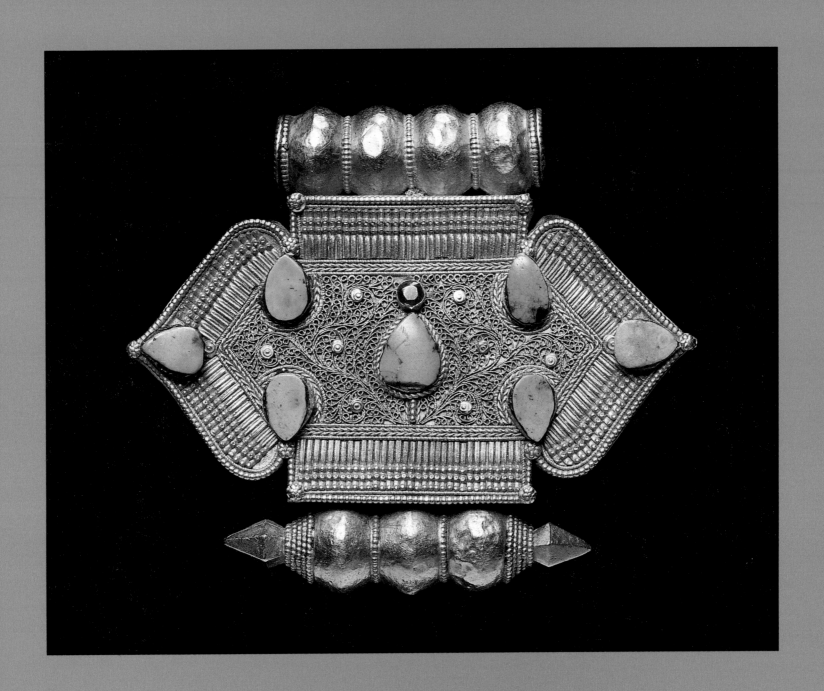

51. Amulet box
Gold, turquoise, glass
H: 9 cm; W: 10.7 cm

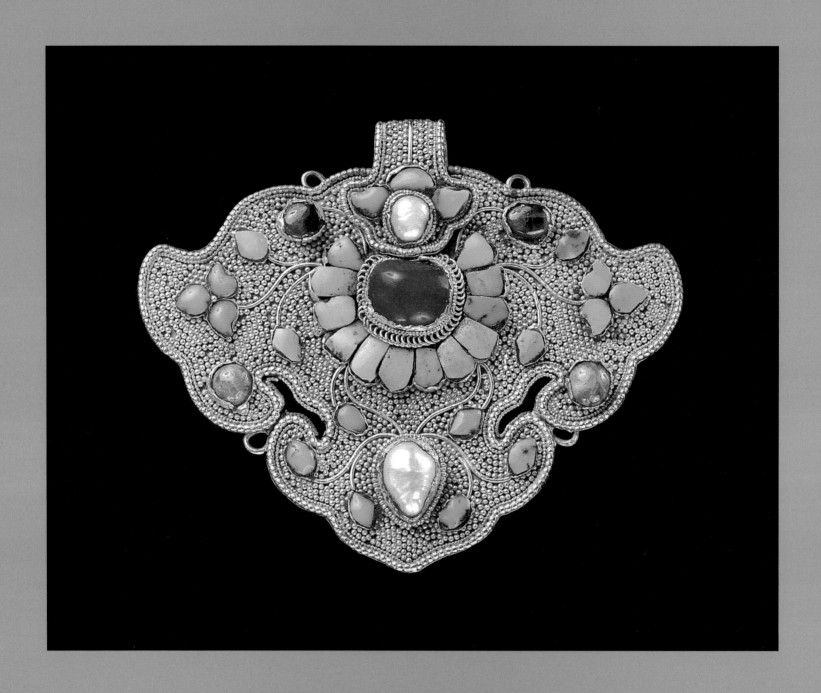

52. Woman's pendant
Gold, turquoise, pearl, coral, other semiprecious gems
H: 5.5 cm; W: 6.5 cm

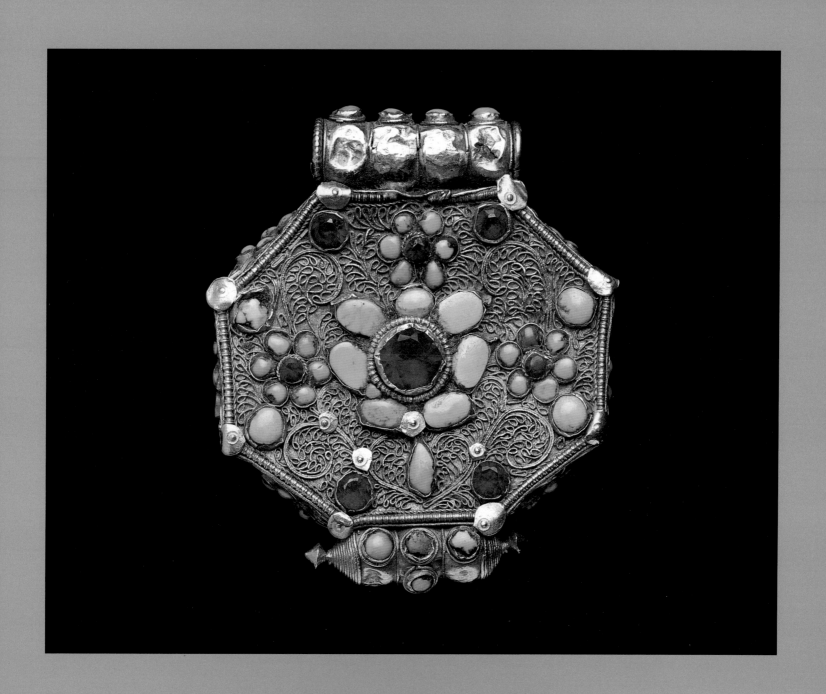

53. Amulet box
Gold, silver, copper (back), turquoise, glass
H: 7.4 cm; W: 6.5 cm; D: 1.7 cm

129

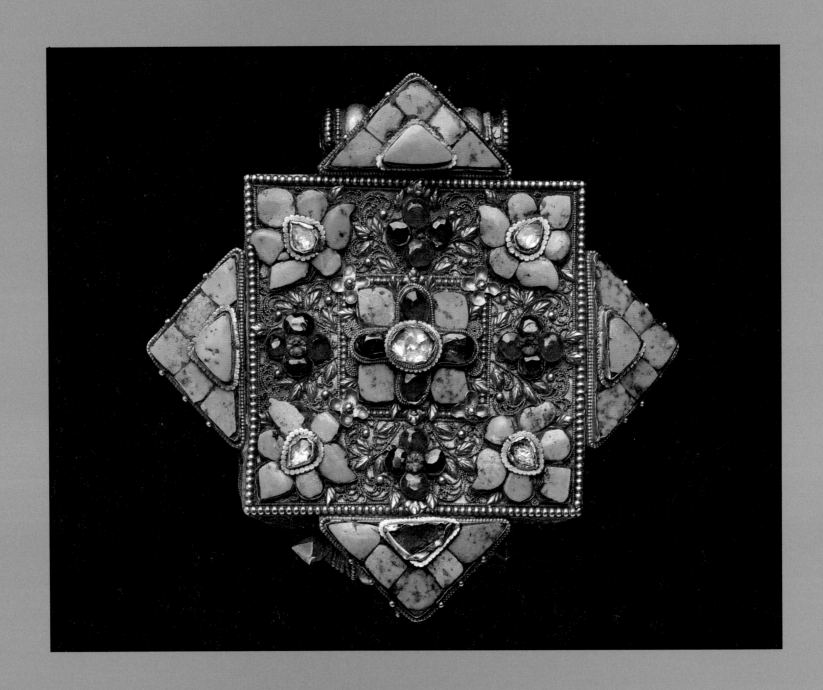

54. Amulet box
Gold, silver, turquoise, glass
H: 9 cm; W: 9.1 cm; D: 1.6 cm

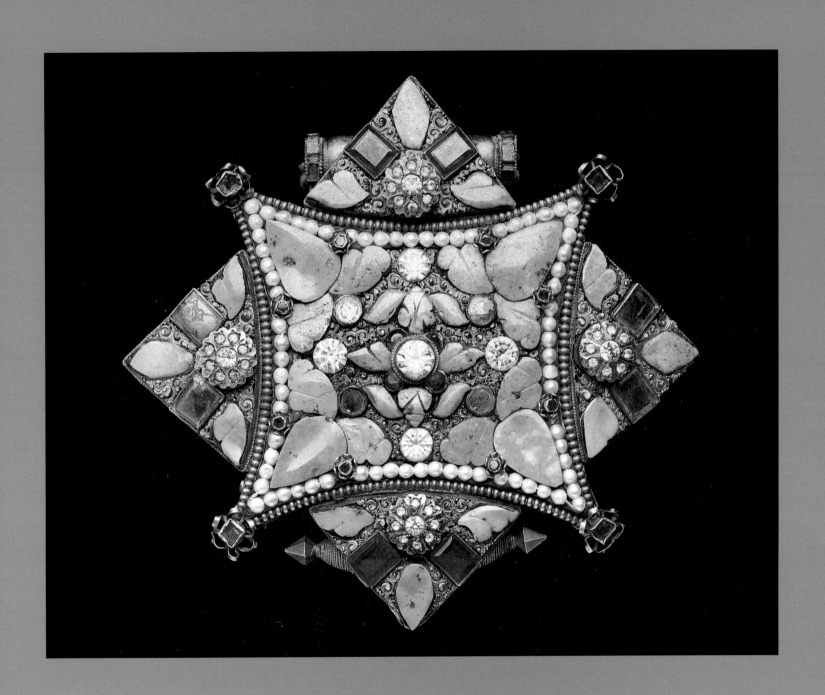

55. Amulet box
Gold, silver, turquoise, pearl, glass
H: 12 cm; W: 13.7 cm; D: 3.2 cm

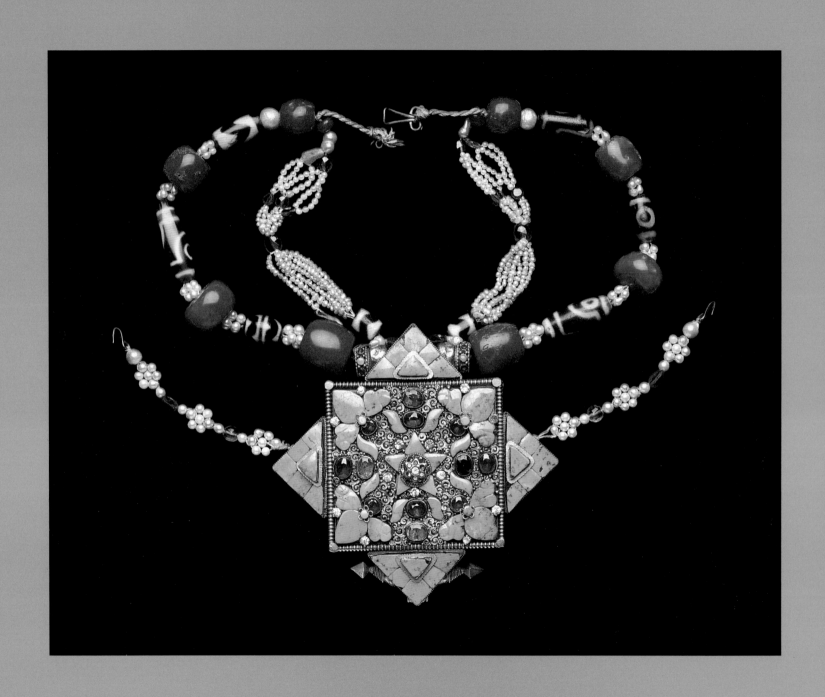

56. Amulet box and necklace attachment
Amulet box: gold, silver, copper, turquoise, glass
H: 12.2 cm; W: 12.7 cm; D: 2.7 cm

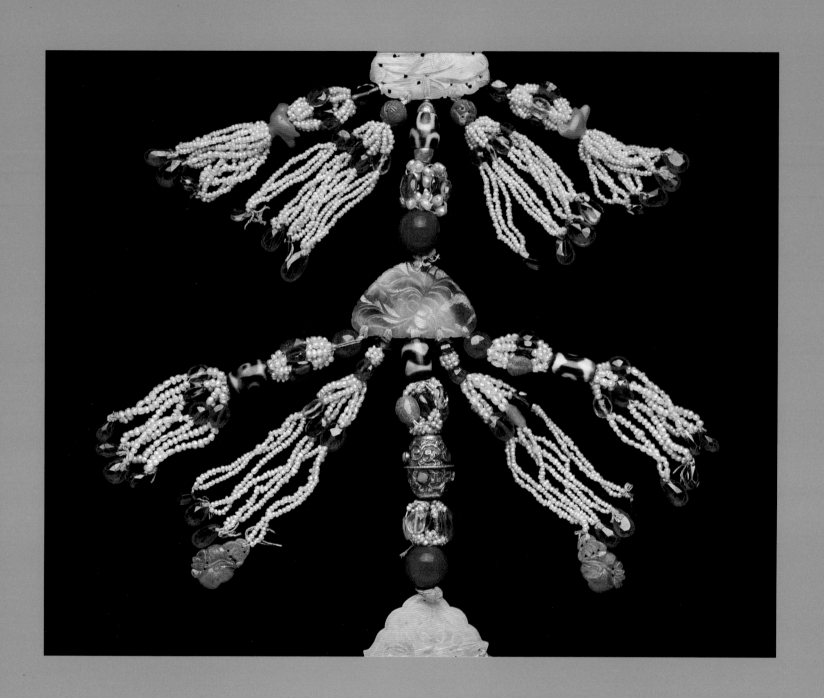

Necklace attachment: coral, pearl, jade, glass, turquoise, gold
Length: 39 cm

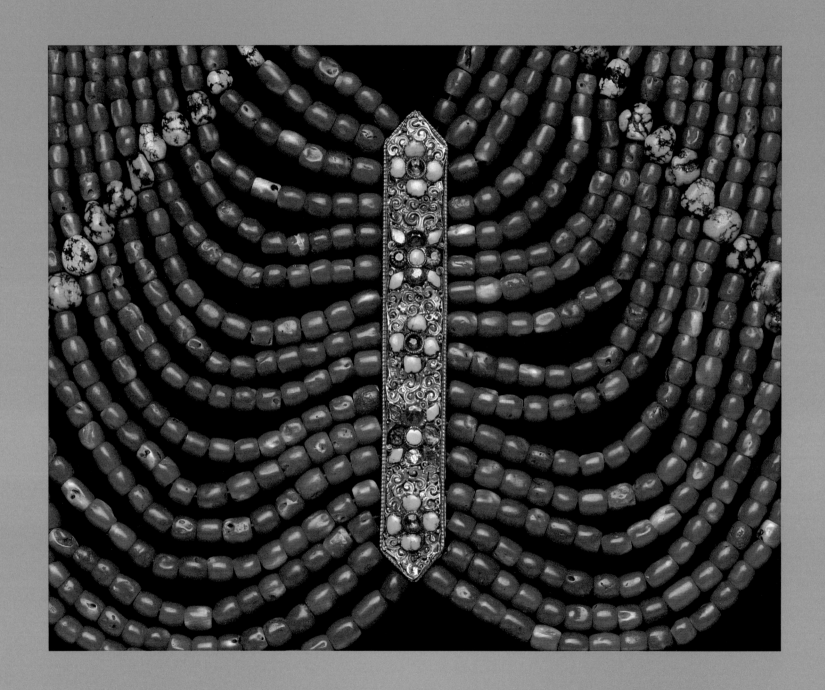

57. Necklace
Coral, turquoise, gold, glass
Length: ca. 40 cm

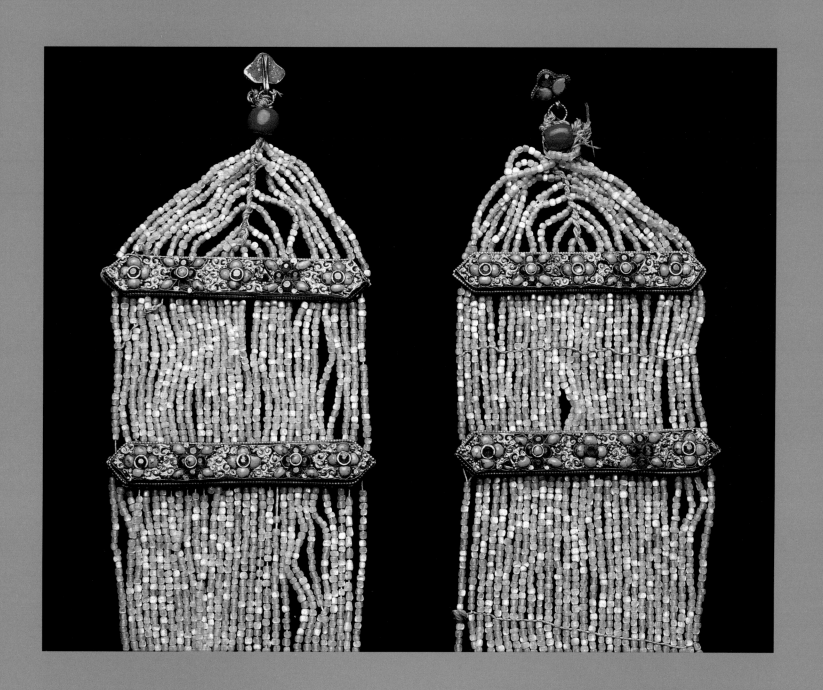

58. Woman's ornaments
Pearl, gold, turquoise, coral, glass
Length: 38.5 cm

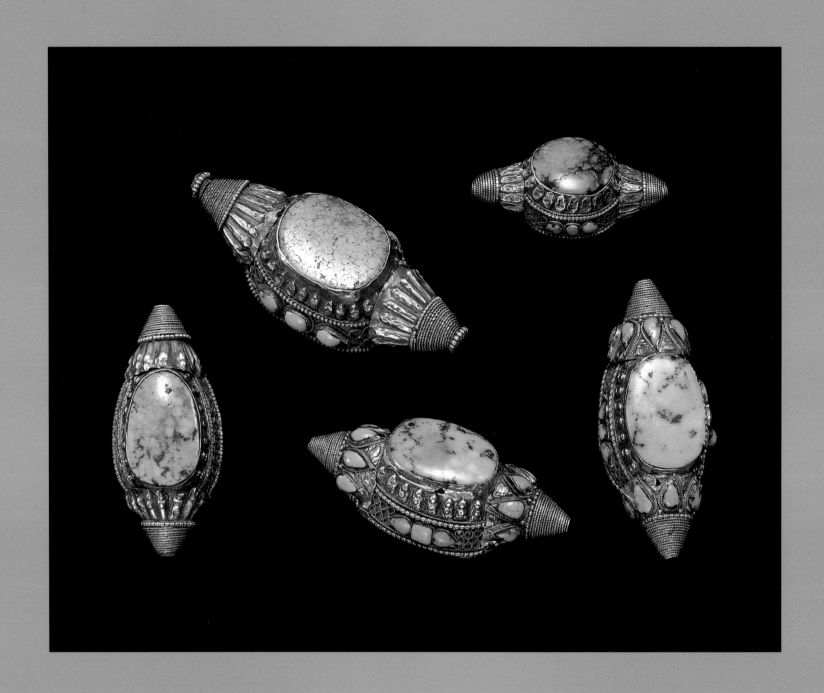

59. Hair ornaments
Gold, turquoise
Each ca. 4 cm length

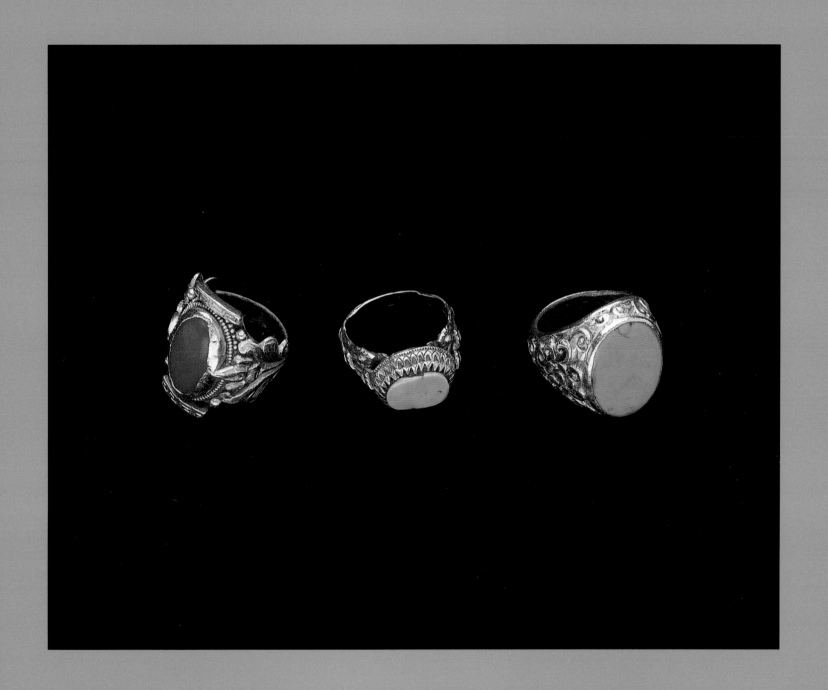

60. Three rings
Gold, turquoise, coral
Each ca. 2.5 cm

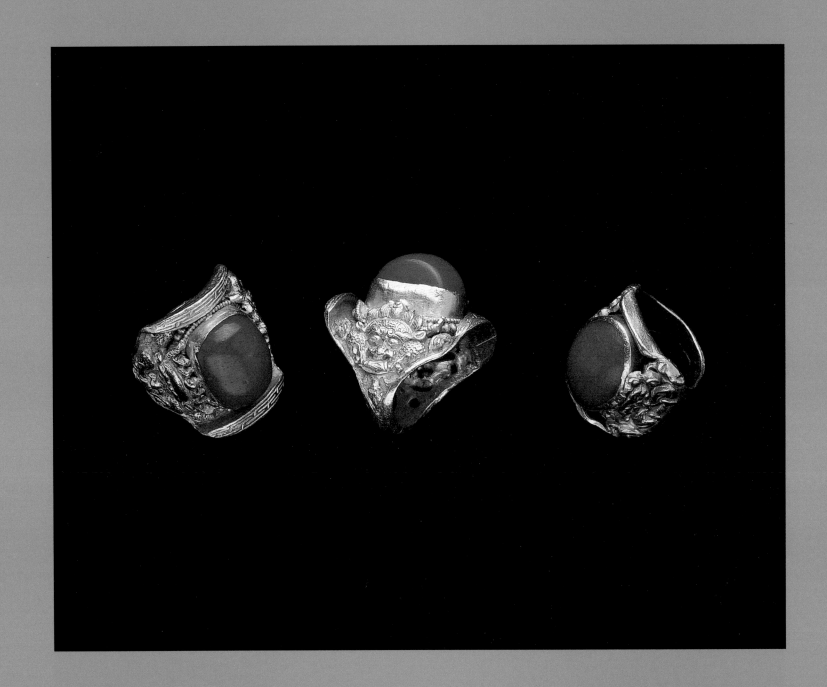

61. Three rings
Gold, coral
Each ca. 2.5 cm

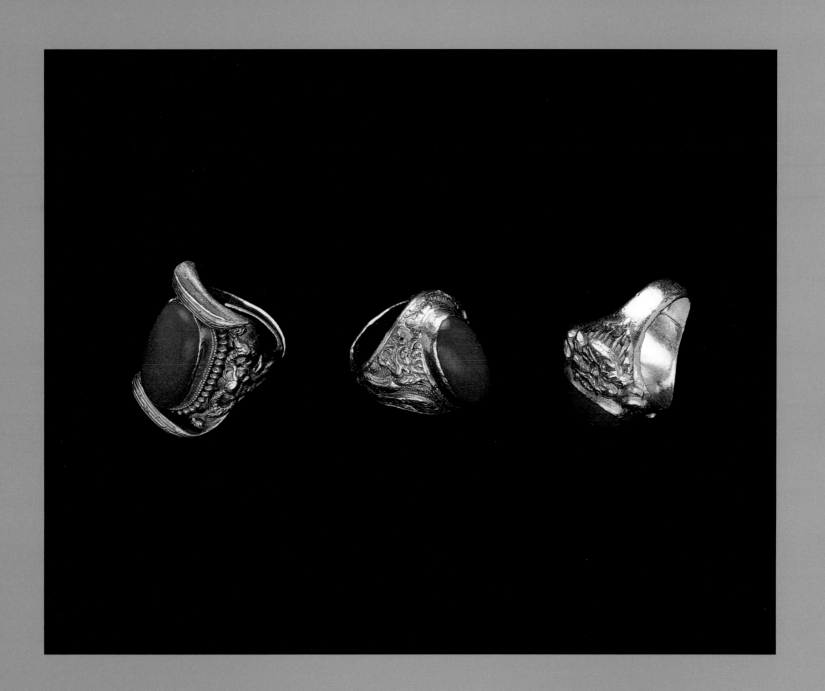

62. Three rings
Gold, coral
Each ca. 2.5 cm

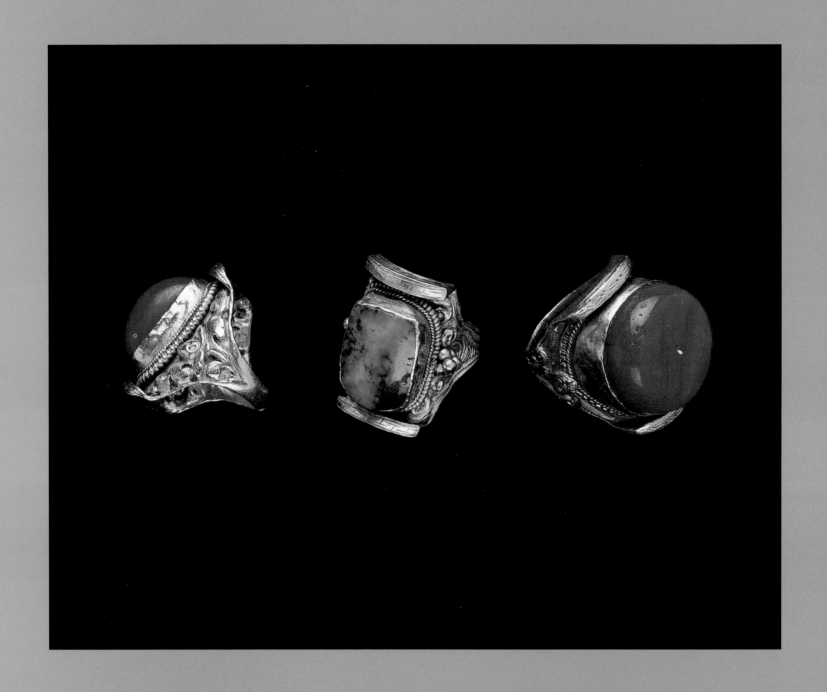

63. Three rings
Gold, coral, turquoise
Each ca. 2.5 cm

64. Three rings
Gold, coral, turquoise
Each ca. 2.5 cm

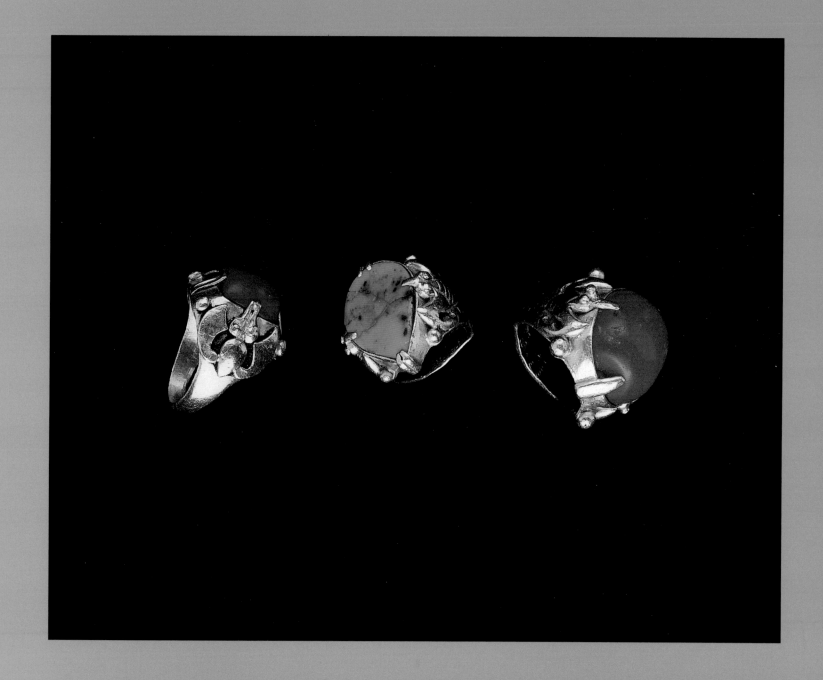

65. Woman's belt
Silver, gold, turquoise
H: 27.2 cm; W: 40.8 cm.

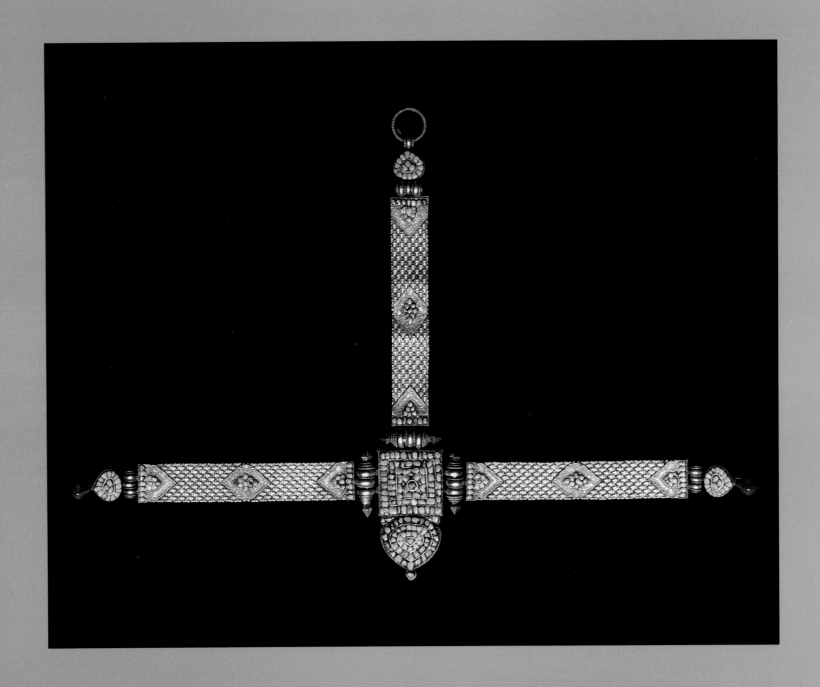